D0125515

U.S.A. $12.95
CANADA $19.95

OVER THE CENTURIES, chickens have been bred into an amazing variety of shapes, sizes, patterns, textures, and colors. Yet because commercial breeders produce only the plain chickens suitable for meat or for egg-laying, most people have no idea these birds exist.

In this charming, newly formatted edition of *Extraordinary Chickens*, author and photographer Stephen Green-Armytage once again opens a glorious window into the world of exotic chickens. With gorgeous color photographs and informative text, Green-Armytage surveys many unusual breeds around the world, capturing with his camera chickens of all sizes, shapes, and colors while also illuminating exotic waddles, "boots," and many other details.

For breeders and enthusiasts, this new volume will be a must to own. For others, it will be a revelation, worth having for the sheer enjoyment of the striking photographs and the amazing animals they portray.

156 photographs in full color

Extraordinary CHICKENS

STEPHEN
GREEN-ARMYTAGE

Extraordinary CHICKENS

STEPHEN GREEN-ARMYTAGE

HARRY N. ABRAMS, INC., PUBLISHERS

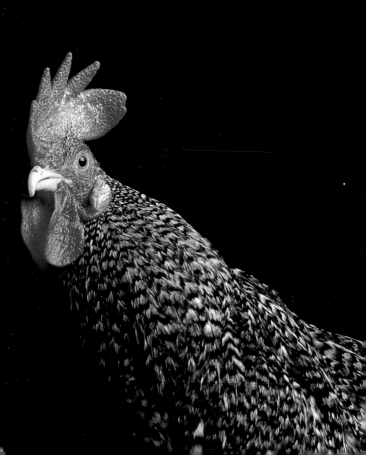

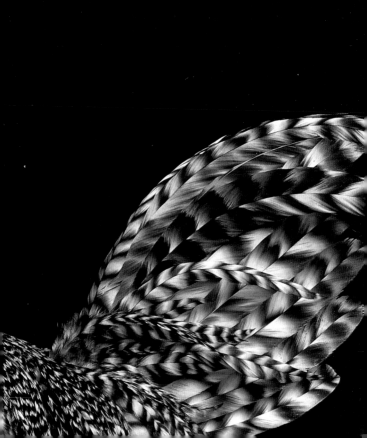

PRECEDING PAGES: SCOTS GREY

OPPOSITE TITLE PAGE:

POLISH *Golden Laced*

Editor: Gail Mandel
Designers: Miko McGinty and Rita Jules
Production Manager: Justine Keefe

Library of Congress Control Number:
2002114938

ISBN 0-8109-9065-2

Copyright © 2003 Stephen Green-Armytage

Published in 2003 by Harry N. Abrams,
Incorporated, New York.

Printed and bound in China
10 9 8 7 6 5 4 3 2 1

Harry N. Abrams, Inc.
100 Fifth Avenue
New York, N.Y. 10011
www.abramsbooks.com

Abrams is a subsidiary of

LA MARTINIÈRE
GROUPE

Contents

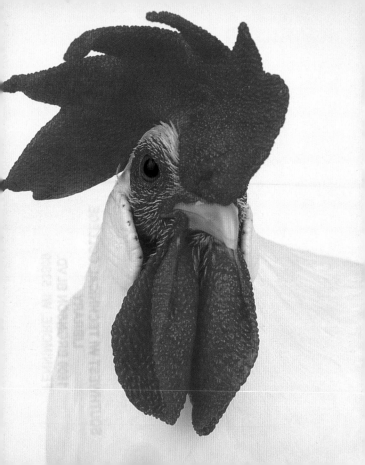

Preface

The aim of this book is to present photographs that celebrate the beauty and variety of chickens, particularly those that have been bred specifically for show. It is not intended as a scholarly or scientific work or as a comprehensive reference book. The birds that we have included were selected either because they are beautiful or because they are strange and interesting.

This project grew out of an assignment for *LIFE Magazine*. I had taken photographs for a feature on unfamiliar dog breeds, and that piece was followed by another, on unusual cats. The readers enjoyed those subjects, and we completed the unofficial series with show rabbits and exhibition chickens. There were far more wonderful chicken photographs than the magazine had space to include, and when I later showed a selection of these to my publisher, they had no hesitation in agreeing that the birds were extraordinary and should become the subject of a beautiful book. Subsequently I have taken more photographs, both in the United States and in Europe, in order to present a wider selection of different breeds.

OPPOSITE: LEGHORN *White Pullet*

Most of the poultry photographs that I've seen in other books have followed a formula well suited to illustrating the physical characteristics of a particular breed, showing a side view of the entire chicken, with its head in profile. Although several of my pictures are in this style, I have not set out to show every specimen this way but instead have chosen to stress the features I find most interesting or distinctive or beautiful. Often this involved the use of close-up photography.

Since I am not a qualified judge of chickens, it may be that I haven't always photographed flawless specimens. Most of the pictures were taken at poultry shows, and usually chickens are not entered in a competitive show unless they are good examples of their type and in good condition at the time. I was often gratified to see that birds I chose to photograph at the beginning of an event were later admired by the judges. However, there may have been occasions when my chosen specimen did not do full justice to a particular breed, even if it was the best that was available at the time. This will probably leave some knowledge-able readers disappointed that their favorites aren't better repre-sented. My apologies if this is ever the case.

I also want to offer apologies to those owners who gener-ously offered their birds for photography only to see those pic-

tures omitted from the book. In aiming for balance, and in trying to show a variety of breeds and colors, we reluctantly had to set aside many good images of wonderful birds.

Whenever possible, I tried to have my subjects brought to my studio table by their owners or by people used to handling chickens. There were times, however, when I was entrusted with the task myself. I found it a very different experience from handling a cat or a dog. Although the birds were not wanting to be tickled or scratched, many seemed content to be stroked. I did this to tidy feathers for the camera but found the smooth feel of the warm plumage to be very pleasant. Some specimens felt extremely strong and athletic, while others seemed delicate and vulnerable.

Although some of my subjects were distinctly restless when asked to be models, most were amazingly cooperative and patient. Only a small percentage flew away and had to be retrieved. None of them attempted to peck at me, and I suffered no wounds from beaks or claws. It wasn't unusual for birds to leave unwelcome souvenirs on my studio table, although for some reason this did not happen in Britain, where the chickens were remarkably well mannered. No hens were thoughtful enough to lay an egg for me, but plenty of them did lay eggs in

their cages during the course of a two-day show. At first this came as a surprise to me, and I realized I was forgetting their traditional role as functional farm animals and looking on them only as objects of beauty.

Another surprise for anyone visiting a poultry show for the first time is the noise. At any given moment, at least one rooster is crowing. I was actually rather moved by these displays of spirit and assertiveness. Here were these creatures who had been manhandled from their home environments into some traveling cage or box, often subjected to long journeys, then manhandled again into a cage in a row of identical other cages, surrounded by birds who are total strangers. While I suppose some are a bit lonely, disoriented, and silent, others immediately set about advertising their presence and presumably declaring their intended territorial dominance or their sexual prowess or something. Meanwhile, a certain percentage of the hens and pullets are clucking away, expressing their feelings about the facilities, the company, the food, and perhaps even the decor.

A few notes for linguistic purists: Technically, the word *chicken* is the plural of *chick*, just as *oxen* is the plural of *ox*. However, as it is common usage to write or speak the word *chicken* for the singular form and to add an *s* for the plural, this is what

I have done here. The term *fowl* includes many other types of birds, such as guinea fowl and peacocks, and the word *poultry* embraces other domestic fowl, such as ducks, geese, and turkeys. Anyway, only chickens are included in this book. In many cases, the male of a breed was more photogenic than the female. To avoid repetition, therefore, I have identified the gender of only those chickens I know to be hens, pullets (young females), or cockerels (young males).

The owners of show chickens seem to be universally helpful and friendly, and I am happy at the possibility that this book will give them pleasure. I also like to think that it can be used by them to show the wonders of their hobby to any friends and family members who might be puzzled by their enthusiasm for "mere chickens." Readers unfamiliar with ornamental chickens will be surprised and, I hope, delighted by the images that follow. I found that when I told city people that I was preparing a book on chickens, I had to preface my sentence with the words, "Don't laugh." This request was always ignored, so all I could say was, "Wait for the book, you'll be amazed."

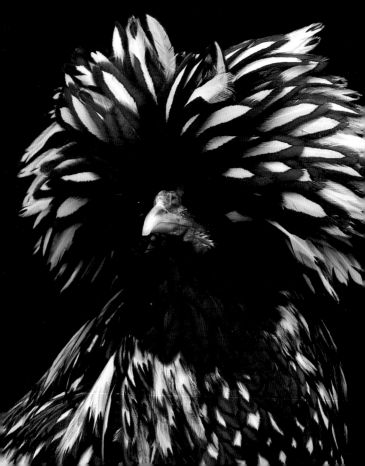

THE STRANGE AND BEAUTIFUL WORLD OF

Exotic Chickens

The concept of exhibiting exotic breeds of chickens is fairly recent, dating from the middle of the nineteenth century, when a few unfamiliar breeds entered Europe and the Americas from the Far East. People were intrigued. Most assumed they had a good idea what roosters and hens looked like, and suddenly they were faced with creatures that were splendidly different but also evidently of the same species.

Farmers saw the possibilities of the imports, most of which were very large and therefore carried more meat. Some laid eggs throughout the winter, and others were tolerant of temperature extremes. Brown eggs were a novelty that fetched higher prices, and

OPPOSITE: POLISH *Silver Laced*

even today many assume that they are somehow more "natural" than the white ones. Fortunately, the imported chickens had few inhibitions about appreciating the charms of the domestic breeds, and vice versa, regardless of differences in size, shape, and color. Thus, breeders were able to experiment to develop birds with combinations of desirable commercial traits.

There emerged a whole new class of breeder—the enthusiast who just wanted to collect, admire, and exhibit strange and beautiful birds. This new attitude also had the effect of opening people's eyes to the variety and quality that already existed in their own domestic breeds. Although these chickens weren't primarily destined for the oven and the table, the birds weren't exactly family pets either. To some extent the owners regarded their beautiful chickens in the same way they might enjoy prize blooms in a flower garden: as living things that needed to be nurtured and cared for and that in return would provide owners with aesthetic pleasure and a degree of creative satisfaction.

In the century and a half that followed, we have seen the rapid development of new chicken breeds, for which we have a fairly well-documented record. Prior to about 1840, however, historical scholarship about chickens is not extensive. We can go

back to around 3,000 B.C. for evidence of domesticated chickens in China. It is thought that these breeds may have originated in India, where, ironically, hard archaeological evidence of chickens dates back only to 2,000 B.C. Chickens appear occasionally in the art and writing of ancient Greece. It is possible that Persian soldiers on military campaigns in India had brought birds back to their land, and that in turn conquering Greeks brought them west from Persia. We also know that different breeds of chickens existed within the Roman Empire and that the same had been true in some Mediterranean countries prior to the rise of the Romans.

When the conquering Romans arrived in Britain two thousand years ago, they were surprised to find some chickens being used for "sport" rather than for meat and eggs. Cockfighting was popular in many countries, and, because warfare was often a part of everyday life in various parts of the world, there was an understandable respect for these little warriors with so much courage and tenacity. (One can see this respect reflected in the names of two of the weight classes used in boxing, *bantam* and *featherweight*.) Some of the current exotic breeds are descended from fighting birds, and many remain aggressive to this day. In these

cases one either has to keep males apart or to allow a natural pecking order (literally) to establish itself through barnyard bravado and battles.

In 1849, Britain banned cockfighting, giving an immediate boost to the interest in breeding ornamental chickens. There had already been some interbreeding of certain aggressive and powerful Asian breeds to produce better fighting birds, and now much of this interest and expertise was diverted to the development of exhibition birds. (Of course, a little discreet cockfighting continued, but the severe penalties for those who were caught were a deterrent.) In addition, chicken shows did involve competition and offered prospects of financial gain; prizes were awarded, and successful birds added value to one's breeding stock, so this alternative to fighting was not an unwelcome substitute.

The first known major poultry show was staged in 1845 at London's Regents Park Zoo, a place filled with interesting wild creatures. Those who attended were not disappointed. Four years later, in 1849, the United States followed with its first breed show, in Boston.

Queen Victoria was an early enthusiast. She had a fine poultry barn built at Windsor for her prized Cochins and Langshans

from China and, later, her Brahmas from India. Other breeders also built housing for their handsome fowl. The creatures who had been barnyard scavengers for centuries were now being well fed and enjoying better living quarters. Victorian times saw an explosion of interest in poultry, and the big shows attracted large and eager audiences.

In the subsequent years, countless thousands of shows of all sizes have been held in many countries. Trying to keep up with shows around the world today would be impossible. In Holland alone, for example, about six hundred shows a year are staged by four hundred and fifty different clubs. At many events, geese, turkeys, ducks, and, occasionally, guinea fowl are included with the chickens. European shows might also include doves, pheasants, and even rabbits and guinea pigs. At big agricultural fairs that feature various types of farm animals, the poultry section is often the most surprising and the most popular, providing many people their first glimpse of what chicken breeders have accomplished during the past century and a half.

Several countries established national associations that undertook to set show standards for each breed. Like similar organizations governing dog and cat shows and livestock events,

they keep track of new breeds as they are established. With poultry, it can be challenging to keep pace with the rapid rate of successful breeding experiments. For example, the German poultry association currently recognizes fewer than half the five hundred breeds that poultry photographers Josef Wolters and Rudiger Wandelt have recorded. Hans Schippers, a biologist and the Dutch poultry authority, estimates that if one were to consider all color possibilities for all breeds, one could come up with a total of seven thousand different varieties. If a show judge were to then split these into adult male and female birds, and also into birds younger than a year old, one could in theory distinguish twenty-eight thousand separate varieties.

Most shows are competitions, with placements and awards being decided in categories designated by the show organizers. Those winners then are judged against each other in broader classifications, culminating in a "best in show" award. These events, particularly the smaller ones, are attended primarily by the owners of the chickens on display. For the owners it is a pleasant opportunity to meet fellow enthusiasts and their birds, to share advice, and, in many cases, to arrange sales, purchases, and exchanges. Usually, outside visitors are attracted only to the more

prestigious events, such as the huge annual show for cockerels and pullets held in Hanover, Germany, and the British National Show in Stoneleigh. In 1995, a show in Nuremberg, Germany, boasted a total of more than seventy thousand birds, a record that will probably be beaten before this book appears. There is a lull in show activity in the summer because few birds are "in good feather" during the hottest part of the year.

HUMAN INTERVENTION has dramatically accelerated the interbreeding of chickens to combine different features of one breed with those of another, and then usually adding a third, and a fourth, and more. This is being done at a rate that would be inconceivable in the wild. Birds that are not domesticated seem to be extremely particular about their mating partners. In looking through a good bird-identification book, for example, one can see pages of warblers with only minor distinguishing markings. Apparently these small differences are sufficient to inhibit mating. Chickens lack these prejudices, although there are some exceptions. For example, crested birds shun noncrested varieties, and the more ancient breeds will not mate with modern, "utility" birds. But while we have fast-forwarded evolution, we have

done so in ways that have replaced "survival of the fittest" with "survival of the prettiest" or, in some cases, apparently, "the survival of the strangest." While commercial chicken operations continuously work toward producing varieties with optimal market value, the number of different types they produce is dwarfed by the number of variations produced by hobby owners.

Manipulating size has long been popular among chicken fanciers. A few breeds exist solely as Bantams, with no full-size equivalents, but the majority were deliberately bred as downsize versions of bigger birds. Some experts insist that these should be called *miniatures* rather than *bantams*. The word *bantam* appears to come from a province on the Indonesian island of Java, the original source of some small chickens. One can see the appeal of these small birds just as one can appreciate the attractiveness to many people of a toy poodle or a miniature schnauzer. Bantams take up less space, eat less food, are more easily handled, and they seem somehow more charming. One hesitates to use the word cute when describing a proud and aggressive rooster, but it often seems appropriate in the case of Bantams.

Even with all the interbreeding, identifying the wild ancestor of the domestic chicken seems to have been surprisingly easy.

Nineteenth-century scientists and naturalists, including Charles Darwin, were aware of five ancient species of wild fowl in Southeast Asia that were possibilities. The Red Jungle Fowl seemed to be the strongest candidate. Fortunately, this bird still exists, although the specimens that are seen in the West may not have a totally uncontaminated hereditary link to the birds of five thousand years ago. Even those captured in the wild in Southeast Asia may incorporate occasional instances of "breeding back" with village chickens somewhere in their genetic history. In any event, recent DNA testing confirms that the Red Jungle Fowl is indeed the true Adam of present-day chickens.

A FEW FINAL NOTES: Because this book is not intended as a scholarly or encyclopedic reference, readers might like to know of a few publications that are. Many of the national organizations for poultry enthusiasts around the world publish books giving detailed descriptions of all the recognized breeds. They include a great deal of interesting information, including details about variations in color and feather patterns.

In Britain, the official book is *The British Poultry Standards*, and the country supports two national organizations, The Poultry

Club of Great Britain and The National Federal of Poultry Clubs. For the Germans there is the *Deutscher Rassegeflügel Standard* and a national organization, the Bund Rassegeflügel Zughter. In the Netherlands is the Dutch Association for Breeders of Poultry and Waterfowl, and the official book is the *Pluimvee Standaard*. In the United States, the American Poultry Association publishes the *American Standard of Perfection*. The 1998 edition is the eleventh revision since 1953, and this association, like others, is constantly updating its lists with new breeds and varieties as they become recognized officially.

In my own research, I have found variations in the names of breeds and in some of the phrases that indicate colors and patterns. For example, I have seen *Owl Beard*, *Owl-Beard*, and *Owlbeard*; similarly, I have come across *Frieseland Fowl* and *Friesian*. All owners of *Silver-laced* or *Golden-laced Polish* birds that I photographed described them that way, but the *American Standard* omits the word laced, even while including it in descriptions for Wyandottes and Cochins with similar feather patterns. Some words have changed with time, and other variations are a matter of regional differences. Please be understanding if my captions don't match your usage.

OPPOSITE: ARAUCANA *Mottled*

24

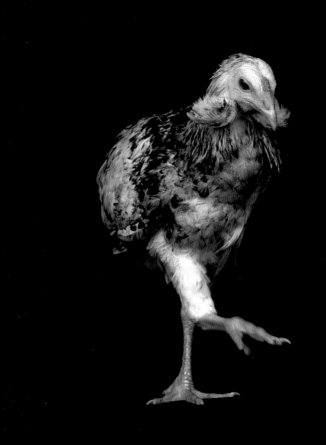

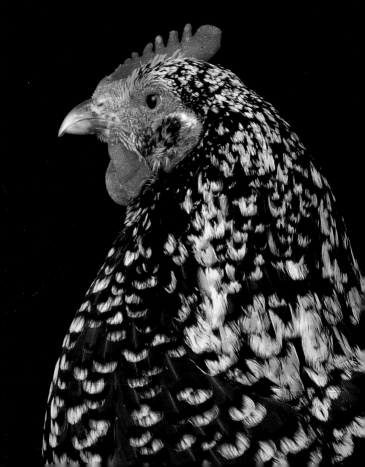

NOTES ON THE
Ornamental Breeds

The following breeds, listed alphabetically,
are featured in this book:

OPPOSITE: SUSSEX *Speckled*

Appenzeller Spitzhauben

The **APPENZELLER SPITZHAUBEN** is not listed in the 1998 *American Standard of Perfection*, but it has recently been recognized in a few European countries. The breed seems to have been a hardy survivor developed over several centuries in the Appenzell territory of Switzerland; the second part of its name comes from the pointed bonnet that is traditional in the area. The late Mrs. Pamela Jackson, with the help of her sister the Duchess of Devonshire, imported, bred, and distributed these birds with enormous enthusiasm. They began their efforts in England in the early 1960s, and in fewer than thirty years the breed had acquired a loyal following.

OPPOSITE:

APPENZELLER SPITZHAUBEN *Gold Spangled*

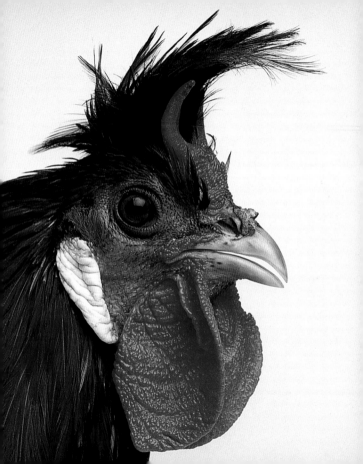

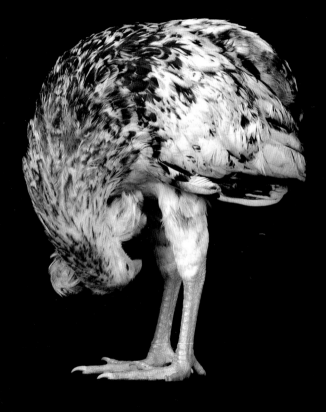

Araucana

The **ARAUCANA** from South America is unique in laying eggs that have a faint green or blue tint. The native Araucas resisted the mating of their birds with those of the conquering Spaniards, thus preserving the character of these chickens. They feature conspicuous feather tufts on either side of the neck. Rumpless Araucanas are popular, although technically this is a subvariety called the Colonca. In the 1970s, breeders came up with a more practical version of the Araucana: the resulting Ameraucana retains the tinted egg color but provides more meat than its ancestor. This breed has ear muffs, rather than ear tufts, and also wears a beard.

OPPOSITE:

ARAUCANA *Rumpless, Mottled*

Aseel

The **ASEEL**, or **ASIL**, is an Indian bird with a two-thousand-year heritage of cockfighting. Today's bird still has all the right attributes; it is muscular, aggressive, tenacious, and energetic. Asil means "noble and pure," and the breed has an air of aristocratic authority.

🖝 For the **AUSTRALORP**, see **ORPINGTON**. 🖝

OPPOSITE: ASIL *Mottled*

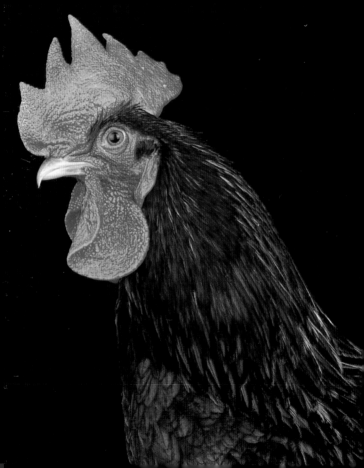

Barnevelder

The **BARNEVELDER** was the result of a plan to develop a large and useful bird that would lay the brown eggs that were appreciated in Britain. The egg color has gradually faded in some countries, and the breed is now appreciated primarily as a show bird. The Dutch are working to reestablish the importance of a dark brown egg. Barneveld is the center of a major chicken-breeding area and is also the site of Holland's fine poultry museum.

OPPOSITE: BARNEVELDER

Belgian d'Anvers

The **BELGIAN D'ANVERS**, known in Britain as the **BARBU D'ANVERS**, is like a confident terrier, relying on speed and boldness and willing to challenge all comers. It can be distinguished from the Belgian d'Uccle by its unfeathered legs and its rosecomb. Both types stand boldly upright. The whiskers give its face the appearance of a small rodent.

OPPOSITE:

BEARDED BELGIAN D'ANVERS

Belgian Bearded d'Uccle

The **BELGIAN BEARDED D'UCCLE** (the **BARBU D'UCCLE**
in Britain) is like the Belgian d'Anvers except that it has
feathered legs. Initially, the exotic specimens with the
Mille Fleur coloring of the d'Uccle attracted the British
and the Americans, and some people simply refer to these
true Bantams by that designation instead of the name
of the breed. The Golden Neck variety is similar and also
very attractive, though with a narrower color palette.

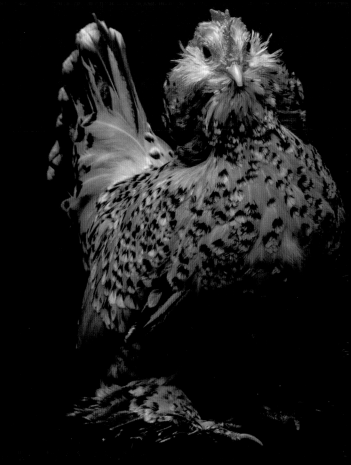

Brabant

The **BRABANT** was common in certain parts of Belgium and was also to be seen on farms in northern France and parts of Holland. It is presumed to be an extremely old breed, not created from any known crosses. Brabant eggs have unusually strong shells.

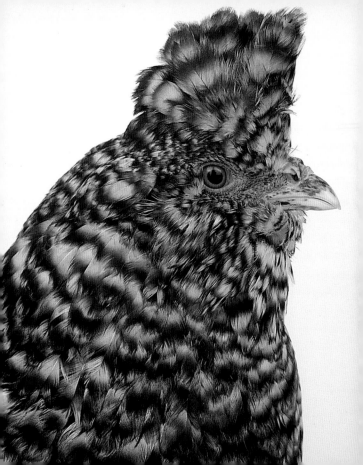

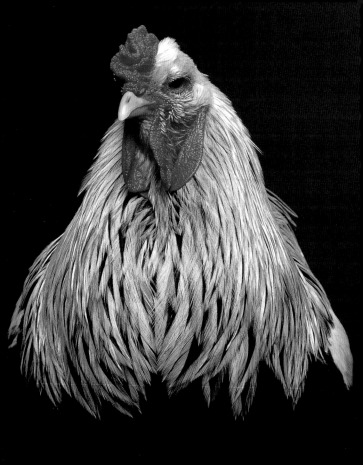

Brahma

Although Europe and the Americas had digested the
startling size of the Cochins and Langshans a few years
previously, the arrival of the **BRAHMA**—with its great
height and the calm dignity of the male—still created
a stir. The first specimens, Light Brahmas, came to the
United States in 1847. Six years later, a group of them
was sent to Queen Victoria by a Mr. Burnham, who cor-
rectly assumed that his gesture would help to increase
the popularity and prestige of the breed. At first the
birds went by the name of Grey Chittagong and, later,
Brahmapootra, after the river in India that may have
been near their place of origin. The latter name was
eventually shortened to Brahma.

OPPOSITE: BRAHMA *Dark*

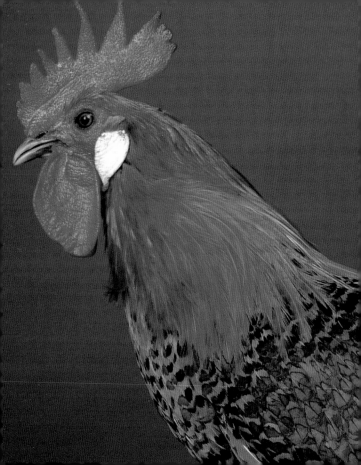

Campine

The **CAMPINE**, from Belgium, is known to have bred true to type for many centuries. The Campine area near Antwerp was never particularly fertile, which accounts for the modest size of the birds. Like some other breeds that caught on as exhibition birds, some of its utilitarian qualities were reduced in the quest for beauty.

OPPOSITE: CAMPINE *Golden*

Cochin

The **COCHIN** was initially known as the Shanghai, and then as the Cochin China in honor of its homeland. The arrival of these large round birds in the United States and Britain in the mid-1840s created a sensation. They weighed ten to twelve pounds but looked even heavier because of their ample soft feathers. The ginger color of the first imports was also a novelty.

OPPOSITE:

COCHIN *Bantam Mottled Hen*

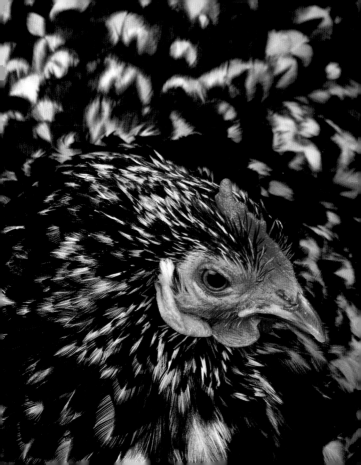

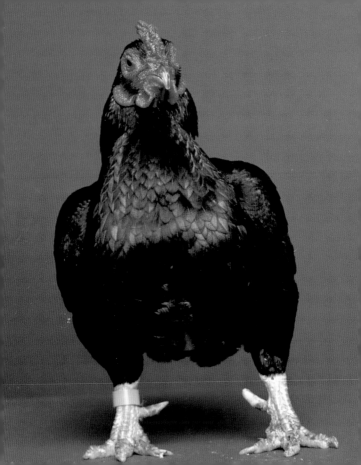

Cornish

The **CORNISH**, known in England as the **INDIAN GAME**, is descended from Aseels and Malays that have been combined with birds local to Cornwall, at the southwest tip of England. In spite of its bulldog figure, the Cornish was never a fighting bird. Its extremely broad breast made it a popular component in the development of commercial hybrids that furnish a good amount of white meat.

For **CROAD LANGSHAN**, see **LANGSHAN**.

OPPOSITE: CORNISH *Bantam Dark*

Cubalaya

The **CUBALAYA** is indeed from Cuba, where it was bred from Malays that had been brought to the island from the Philippines and Florida. Subsequently some European blood was added. The Cubalaya has an unusual stance, with the neck and shoulders held high and forming the top of a diagonal line that slopes down through the back and the tail. This is a handsome bird with a wild and exotic appearance, and it has been recognized in the United States for more than sixty years. It is surprising, therefore, that one rarely sees Cubalayas at poultry shows.

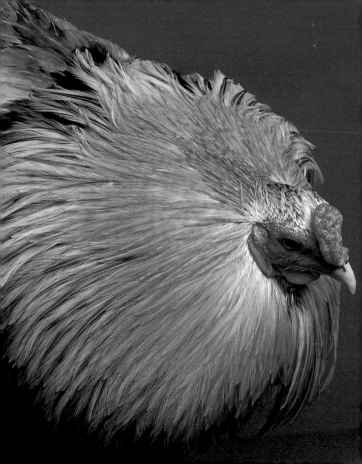

Drente

The **DRENTE** is a Dutch breed that appears to be pretty much unchanged over the last two hundred years. Archaeological research traces it to Roman times, and it is closely related to the Red Jungle Fowl.

OPPOSITE:

DRENTE FOUL
Rumpless Yellow Partridge Pullet

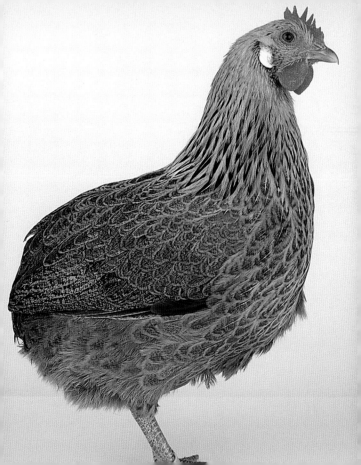

Dutch Bantam

DUTCH BANTAMS appear to be among the oldest of the Bantams and are sometimes referred to as Old Dutch.

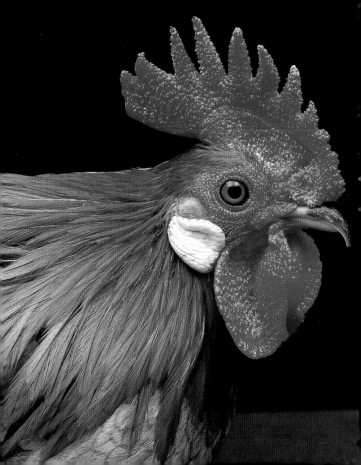

Faverolles

The **FAVEROLLES** originated in the French village of the same name. Faverolles is close to the town of Houdan (see page 67), and the two towns' chickens also seem closely related. The Faverolles also contains some Dorking and Brahma strains in its ancestry.

OPPOSITE:
FAVEROLLES *Salmon Hen*

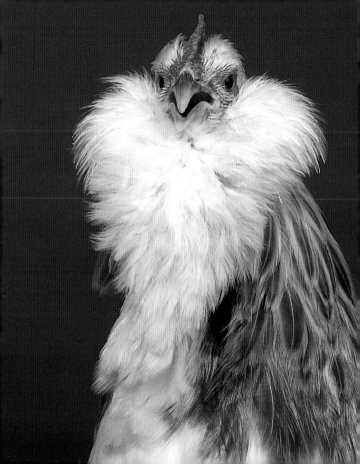

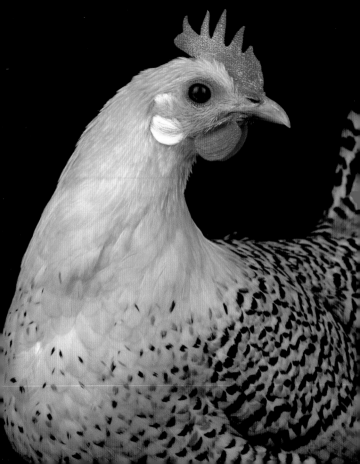

Friesian

The **FRIESIAN**, from northeastern Holland, is another excellent egg layer. These birds are also capable of sustained (long-distance) flight.

Frizzle

Technically, a **FRIZZLE** chicken refers not to a breed but to a distinctive type of feathering that curls away from the body. Darwin observed that Frizzles were "not uncommon in India," where they are also called "Caffie Fowl," and it is assumed that they originated there. Breeders must take care not to allow feathers to become too brittle and delicate, and every few generations a non-Frizzle bird has to be included in the mix to prevent this.

OPPOSITE:
PLYMOUTH ROCK FRIZZLE *Buff*

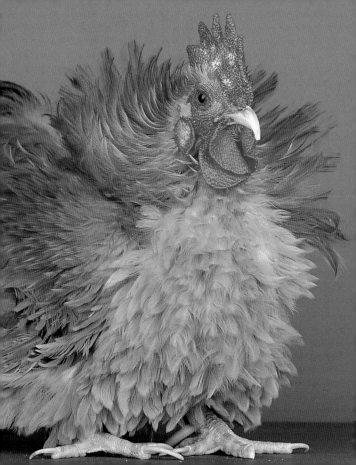

Frizzle Polish

The **FRIZZLE POLISH** hybrid was conceived and achieved by Arie Boland of the Netherlands, and the result is a truly amazing creature. Many birds and many generations—not to mention intelligence, experience, and knowledge of genetics—were involved, plus quite a large sum of money—so far an estimated $20,000. Not only has Mr. Boland succeeded in creating a unique breed, but he has also done so in several different colors.

OPPOSITE:
POLISH FRIZZLE
Bantam Bearded Blue Hen

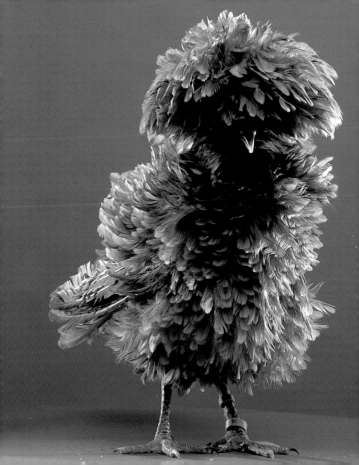

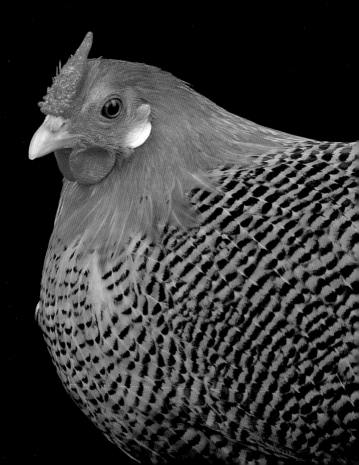

Hamburg

The **HAMBURG** (or Hamburgh in Britain) is not actual-
ly from Germany but rather from Britain and Holland.
The Lancashire Mooney and the Yorkshire Pheasant
seem to be among its combined ancestors.

OPPOSITE:

HAMBURG *Gold Penciled Pullet*

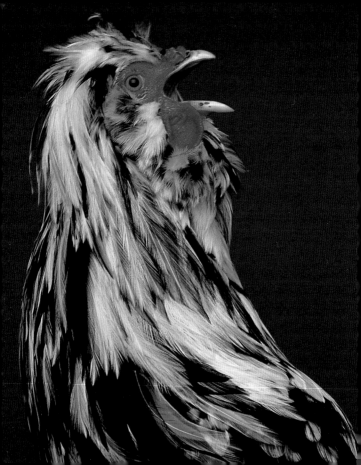

Houdan

The **HOUDAN** is a general-purpose French breed prized
as a layer of large eggs and for the quality of its meat.
The town of Houdan is in southern Normandy, and the
breed was once referred to in Britain as the Normandy
Fowl, perhaps not distinguishing it sufficiently from
the Crèvecoeur chicken, named for another nearby
town in Normandy. Darwin classified both these crested
birds, together with the Polish (see page 104), as sub-
species of the same breed. However, unlike the others,
the Houdan has a fifth toe, suggesting a possible com-
mon ancestry with the Dorking.

OPPOSITE HOUDAN Mottled

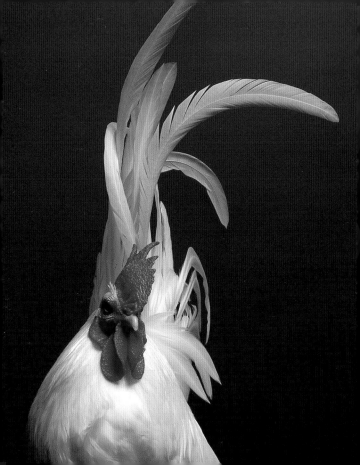

Japanese

JAPANESE BANTAMS, also known as **CHABO BANTAMS**,
were imported to Holland in the seventeenth century,
but for a long time they were rare because of Japan's
insular trade policies. No other breed features a male
holding its tail feathers so erect; often they come close
to touching the back of the head.

OPPOSITE:
JAPANESE *White*

Kraaikop

The Dutch breed known as the **KRAAIKOP** is unusual
in that the shape of the head is like that of a crow.

OPPOSITE:

KRAAIKOP *Cuckoo*

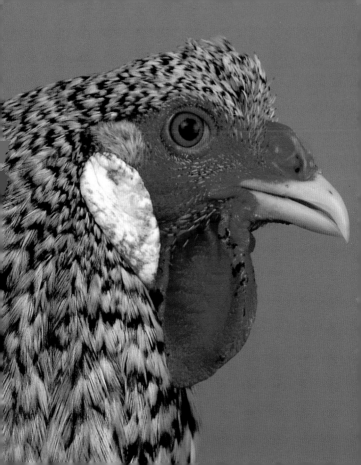

La Flèche

The **LA FLÈCHE** is an excellent meat bird from a town of the same name in the Loire valley in France. It is related to the Polish and the Crèvecoeur but, unlike those two, has no crest to diminish the effect of the "devil's-horn" split comb.

OPPOSITE: LA FLÈCHE

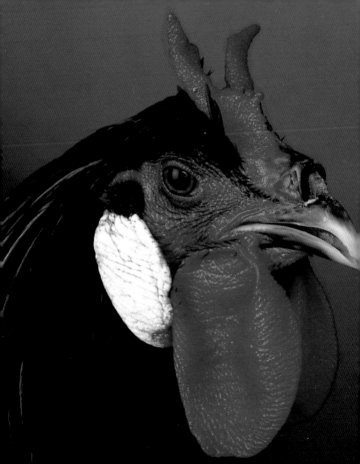

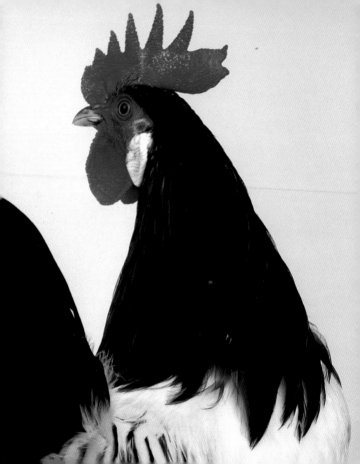

Lakenvelder

The **LAKENVELDER** is thought to be a German breed from Hanover and Westphalia but may be from Holland originally. It is believed to be related to the Belgian Campine. Mysteriously, it was once thought to have origins in Jerusalem.

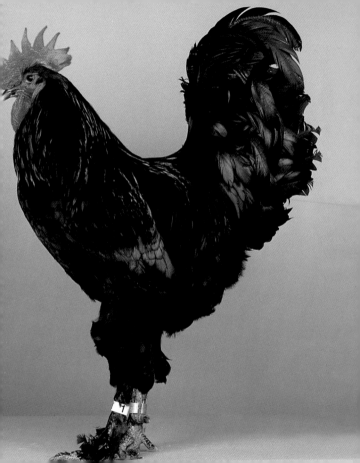

Langshan

The **LANGSHAN** was imported directly to England from Langshan, China, by a Major Croad in 1872, just ten years after the Yangtze River was opened to foreign trade. Known in Britain as the **CROAD LANGSHAN**, the bird today has a tall, upright carriage that is distinctive to its breed, yet when Black Langshans first arrived in Britain, some mistook them for Black Cochins. Miss Croad, the Major's daughter, made return trips to China to bring back more birds to solidify the acceptance of this separate breed (though the brown color of the large eggs should have been sufficient to establish the difference). Many communities in China had been very insular, and breeds could sometimes develop quite separately from others that were not far away.

OPPOSITE: LANGSHAN *Black*

Leghorn

The **LEGHORN** gets its name from Livorno, which is one of a handful of Italian towns that have Anglicized versions of their names. The name Leghorn was also given to a floppy style of hats from Italy, and, because the female chickens had combs that flopped over to one side, the mother of Mr. Acker, the first American to acquire the breed, gave it the name Leghorn. First shipped to the United States in 1874, the Leghorn is a very reliable layer of eggs and is an important element in the makeup of commercial egg-producing hybrids.

OPPOSITE:
LEGHORN *Bantam White*

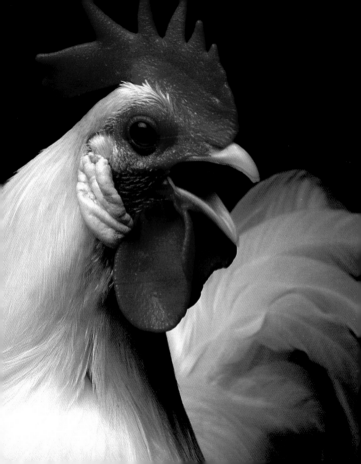

Malay

The very tall **MALAY** is thought to be an ancestor of some of the large Asian breeds, and Malay specimens reached Europe earlier than they did. It is also known to be the ancestor of the Modern Game, and its effectiveness as a fighting bird caused its popularity to spread from the Malay Peninsula into other parts of Southeast Asia.

OPPOSITE:

MALAY *Black Breasted Red*

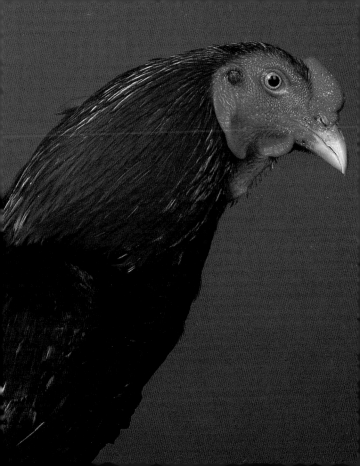

Minorca

The **MINORCA** is a large bird from Spain, specifically from Menorca, the second-largest of the Balearic Islands. The males have an impressive single comb, but the hen's comb falls to one side. For around two hundred years, the Minorcas have been popular in southwest England, the warmest area in Britain, whose ports enjoyed active trade with Spain. The size of Minorca eggs is exceptional. This breed is sometimes referred to as the **SPANISH RED FACE** to distinguish it from another breed, the Spanish White Face (see page 121).

OPPOSITE: MINORCA *White*

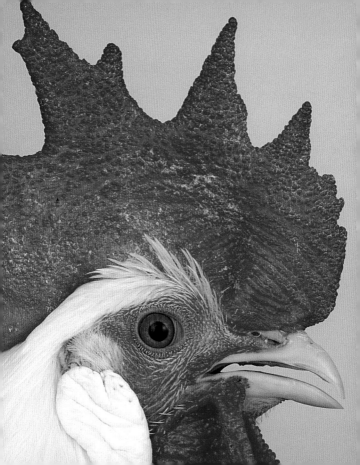

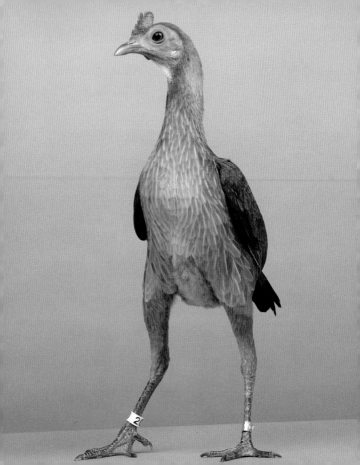

Modern Game

As their name suggests, **MODERN GAME** chickens are
descended from fighting birds. To some people, the
slim silhouette looks wrong for a chicken, but others
find it elegant. Further height was introduced via the
Malay, but today the Bantam Modern Game is more
popular than its full-size counterpart.

OPPOSITE:

MODERN GAME
Bantam Wheaten Pullet

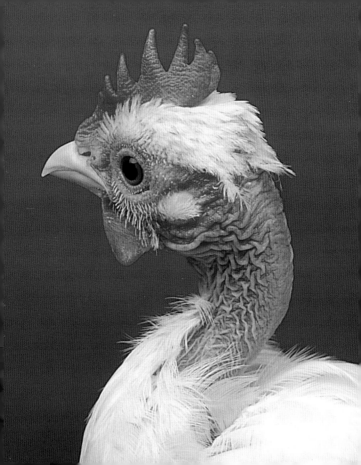

Naked Neck

The **NAKED NECK**, sometimes called the **TRANSYL-VANIAN NAKED NECK**, is also known as the **TURKEN**, as it combines the bare neck of a turkey and the body of a chicken. It comes from Eastern Hungary. Though some find the type unattractive, the Naked Necks have a number of practical advantages—they start laying eggs very young and continue to do so throughout the winters; they are also capable foragers and seem virtually immune to disease. Further, the meat is excellent and the feathers pluck easily (some are missing already).

OPPOSITE:
NAKED NECK *White Hen*

Old English Game

Like the Modern Games, **OLD ENGLISH GAME** birds were once bred for fighting, and their tails would be *docked* (cut short) to eliminate the possibility of an opponent using those feathers as a beak hold. For the same reason, combs and wattles were *dubbed* (trimmed or removed). Some roosters retain an aggressive attitude, and adult males may need to be kept apart for their own safety. Hens can be fierce in the defense of their chicks. The Old English Game Bantams are

extremely popular and include an enormous range of color possibilities. British versions of the Old English Game come in a slightly different style, actually two different styles. Those with a more direct fighting lineage are known as **OXFORDS** and show a sharper angle between the line of the back and the rise of the tail. The **CARLISLE** type has a more horizontal stance and a broader breast; the tail is held lower and has pronounced sickle feathers on either side.

OVERLEAF:

OLD ENGLISH GAME *Black*

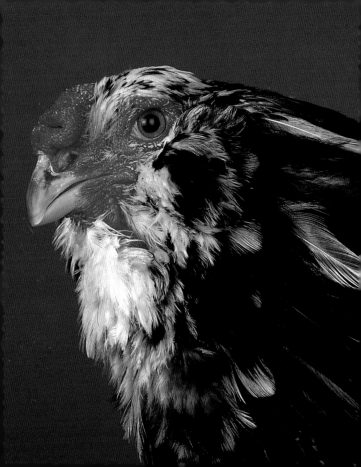

Russian Orloff

The **RUSSIAN ORLOFF** may have come close to extinction when large exotic birds from eastern Asia became sought after and interest in these previously impressive birds declined. Although bred in Russia for a long time, these birds came originally from Persia (present-day Iran) and also had Malay ancestry.

OPPOSITE:
RUSSIAN ORLOFF

Orpington

For a time, Britain produced two similar types of black chickens, but the one developed by William Cook of Orpington in southeast England became the officially recognized breed. Apparently the original **ORPINGTON** breed mix included strains of Langshan, Cochin, Minorca, and Plymouth Rock. When he came up with a **BUFF ORPINGTON**, Mr. Cook was again challenged for the right to qualify a new breed, this time by supporters of the Lincolnshire Buff, but again Mr. Cook prevailed.

While British breeders refined the Orpington to score show points at the expense of utility, Orpingtons taken earlier to Australia were maintained as a practical breed. When some Australian birds reappeared in Europe, they were scorned as coarse and unrefined, and their supporters naturally had little respect for those birds with diminished functional assets. The solution was to create a new name for the Australian version, and so the Australorp was born.

OVERLEAF:
ORPINGTON *Buff*

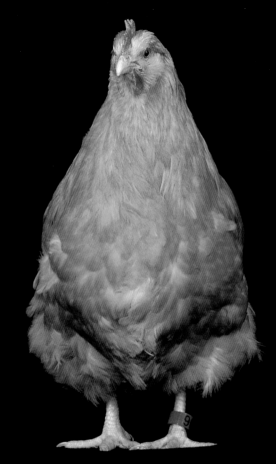

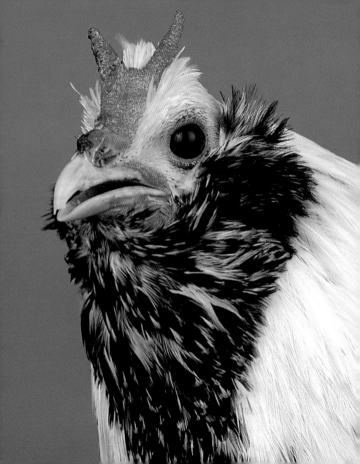

Owlbeard

The Dutch **OWLBEARD** has a split or horned comb, which distinguishes it from the otherwise similar Thuringian Bearded Fowl in Germany.

Phoenix

The **PHOENIX**, or **ONAGADORI**, is the result of at least four hundred years of breeding to create exceptionally long tails. Sometimes used to decorate a warrior's lance, these feathers were also a matter of prestige to Japanese land-owning aristocrats. Farmers could ingratiate themselves with the master by producing and caring for these spectacular specimens. The birds do not molt, and tail lengths of more than 20 feet are possible; the *Guinness Book of World Records* reports one bird with an amazing tail of 34 feet, 9 1/2 inches.

OPPOSITE:
PHOENIX *Golden Duckwing*

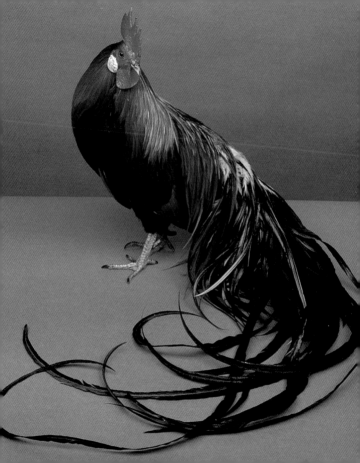

Plymouth Rock

The **PLYMOUTH ROCK** was created in New England in the latter half of the nineteenth century and quickly became a favorite for both farmers and exhibitors. It was equally successful when shipped to Britain in 1879. The breeding mix included Dominique, Cochin, Brahma, Java, Minorca, and Leghorn.

OPPOSITE:

PLYMOUTH ROCK *Barred*

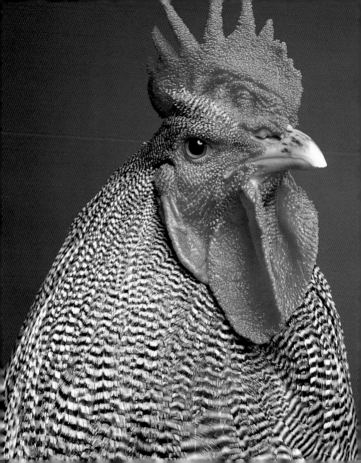

Polish

They are known as **POLISH** in the United States and **POLAND** in Britain, yet the breed is believed to have originated in Italy (in some languages they are called **PADUAN** after that part of Italy) and been brought to its present state of development in Holland (sometimes they are referred to as **CRESTED DUTCH**). Because they were common in Eastern Europe, these crested birds may well be named for Poland, but there is speculation that the River Po in Italy is the source of the

name or that the name refers to the *poll,* an old (Middle English) word defined as "the top of the head." Polish crest feathers grow from a knob or small dome on the top of the skull. The crest feathers are fairly neat and rounded on the females and more extravagant, unkempt, and pointed on males. One might worry about the birds' ability to see where they are going, but the crests don't obstruct their downward vision, the direction they need to look when feeding.

OVERLEAF:
POLISH *White Crested Black*

Rosecomb

With no full-size counterpart, the **ROSECOMB** is a true Bantam. Its comb ends in a spike, like that of the Hamburg, and the earlobes are a clean white.

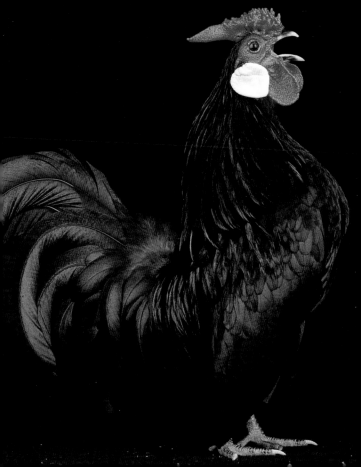

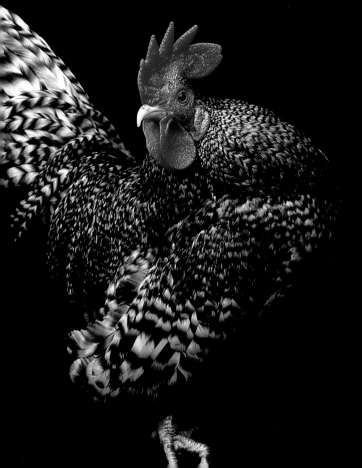

Scots Grey

The **SCOTS GREY** is, not surprisingly, a hardy bird, able to withstand the cold, wet winters of Scotland. Its long legs help it to move through the rugged landscape in search of food. The breed dates back at least to the sixteenth century, and probably beyond.

OPPOSITE: SCOTS GREY

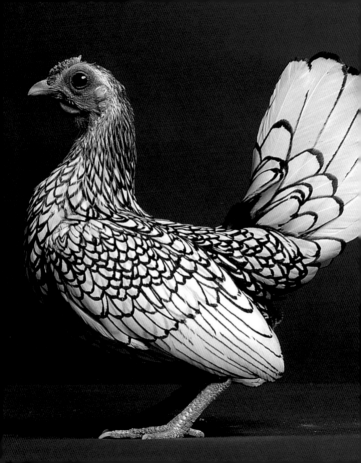

Sebright

SEBRIGHTS are true Bantams with no full-size equivalents. When Sir John Sebright developed the breed nearly two hundred years ago in Britain, he initially arrived at the Golden Sebrights, then used them as a starting point for breeding a Silver version.

OPPOSITE:

SEBRIGHT *Silver Hen*

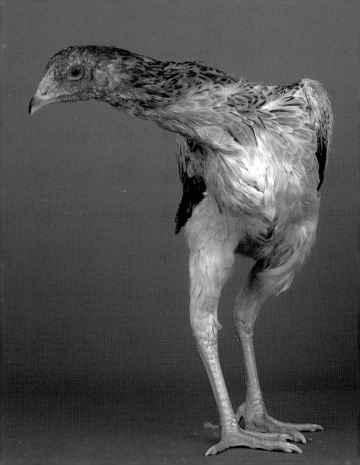

Shamo

The **SHAMO** was a popular fighting bird in Japan for many centuries and is one of the world's oldest breeds. Its ancestor was the Malay. This is a very tall bird, heavy, strong, and agile, and with a suitably pitiless expression.

OPPOSITE:

SHAMO *Wheaten Hen*

Sicilian Buttercup

The shape of the **SICILIAN BUTTERCUP'S** comb is unique. Ideally, it should look rather like a primitive royal crown, cup shaped and symmetrical, with points like those on Lady Liberty's head.

OPPOSITE:

SICILIAN BUTTERCUP

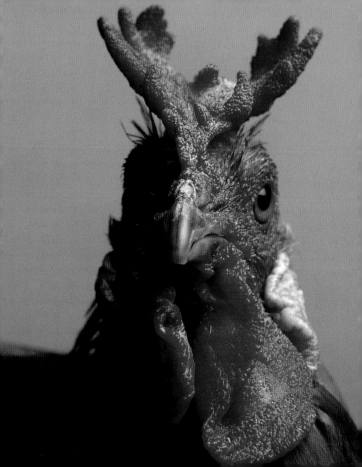

Silkie

The unique feather structure of the **SILKIE** makes this chicken look more like a fluffy mammal than a bird. Marco Polo was probably referring to Silkies when he wrote of seeing chickens with wool rather than feathers in India and the Far East. Specimens did not reach Europe until the middle of the nineteenth century. The Silkie's earlobes are a light blue, and the color of the comb and wattles has been described as "mulberry."

OPPOSITE:
SILKIE *Bantam Bearded Black*

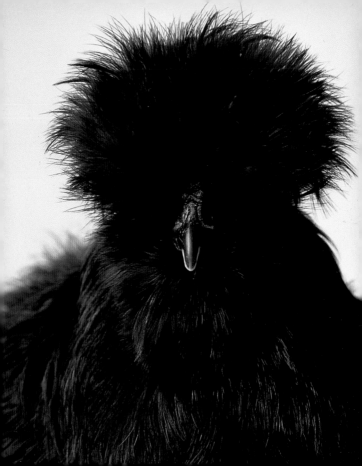

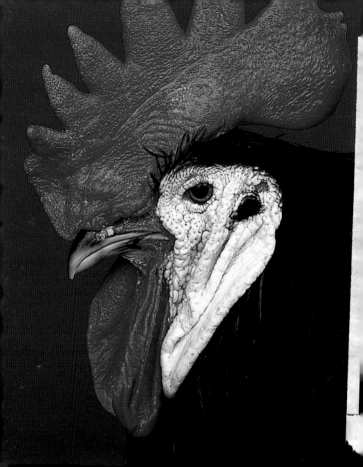

Spanish White Face

The **SPANISH WHITE FACE** looks as if it belongs at a masked ball or carnival. It is a very old breed, prized for its large white eggs, although it has lost some of its hardiness by being kept indoors to preserve the clean white of the face for show purposes.

OPPOSITE:

SPANISH WHITE FACE

Sultan

SULTANS were first brought from Turkey to England in the 1850s and to the United States about ten years later; they were recognized in the *American Standard* in 1874. One assumes Polish genes, but the vulture hocks and well-feathered feet come from elsewhere. The Sultan had found favor as an ornamental breed in Turkey, but in spite of its striking appearance, it never caught on widely in the rest of the world.

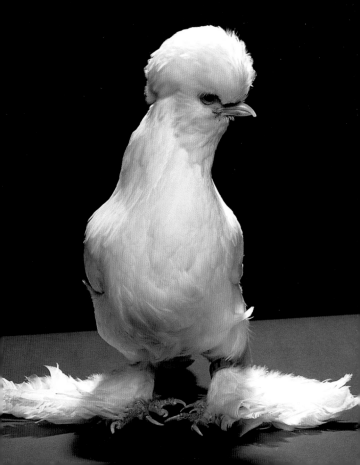

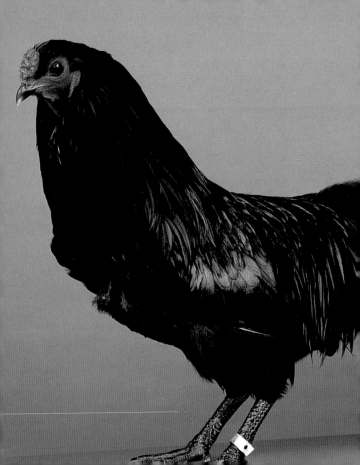

Sumatra

The **SUMATRA** is indeed from the island of Sumatra, but these gregarious birds were capable of flight between there and the island of Java. Locals tended to regard them as pheasants because they show a very horizontal line from the neck to the tail and have a rather pheasantlike head. Used locally as a fighting bird, the first Sumatras to reach America in 1847 were also used that way. It took another fifty years for the breed to appear in Britain. The males often develop complex and unusual spurs.

OPPOSITE:
SUMATRA *Black*

Sussex

The **SUSSEX** was bred around a hundred years ago as a utility bird, and, together with the Cornish (Indian Game), it contributes to the hybrid that is the modern supermarket broiler. At the same time, the Sussex has remained popular for small farms and often does well at poultry shows.

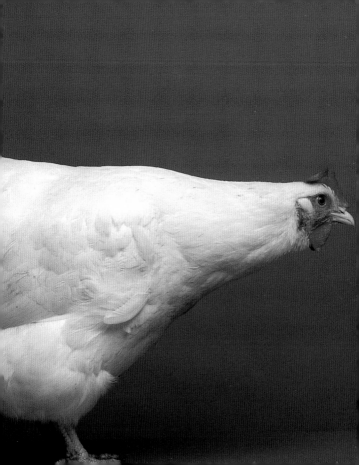

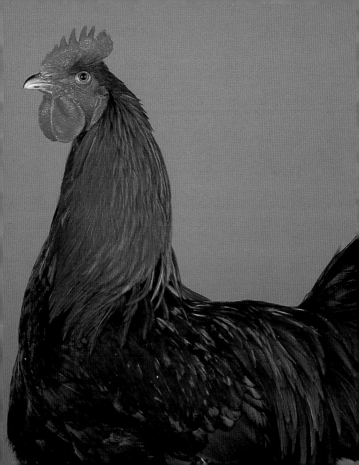

Welsummer

The **WELSUMMER**, a Dutch breed named for the village of Welsum, lays eggs that have a rich dark brown color, sometimes with spots and speckles.

OPPOSITE:

WELSUMMER

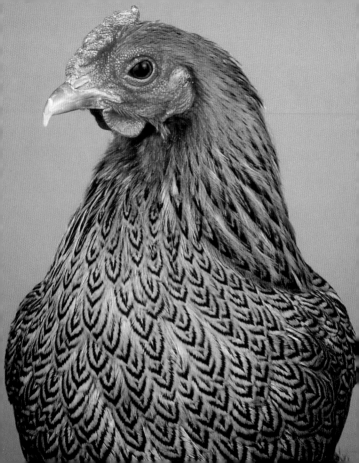

Wyandotte

Named for a Native American tribe in New York State, the **WYANDOTTE** was developed in the second half of the nineteenth century. It was initially the result a cross between the Cochin and the Silver Sebright. Over time, other breeds have been incorporated in order to manipulate the size and to add other colors and patterns.

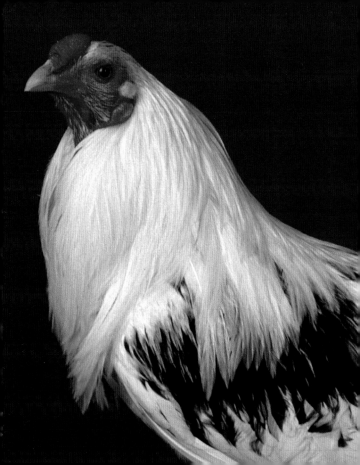

Yokohama

Bred in Japan and Korea for hundreds of years, the
YOKOHAMA has a pheasantlike appearance reminiscent of the Sumatra. The breed first came to Europe
in the 1860s, and the Germans became skilled at developing the long tails. Yokohamas weren't officially recognized by the *American Standard* until 1981.

OPPOSITE:

YOKOHAMA *Red Shoulder Cockerel*

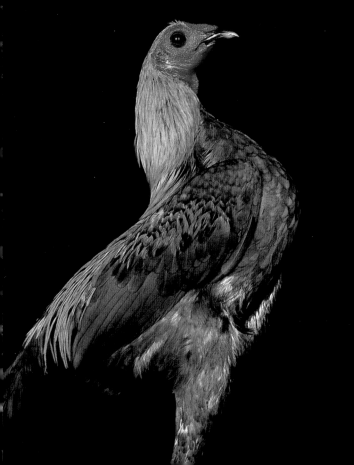

INTERNATIONAL
Portfolio

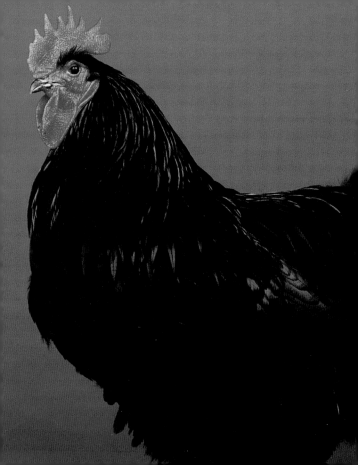

AUSTRALORP *Black*

OVERLEAF:
AMERAUCANA *Blue Wheaten*

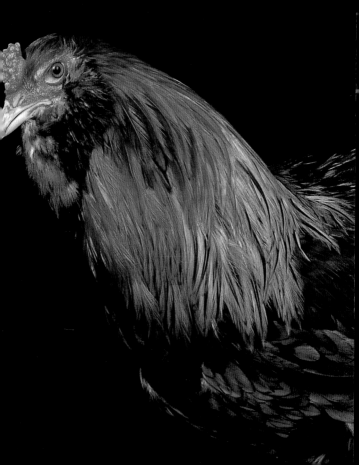

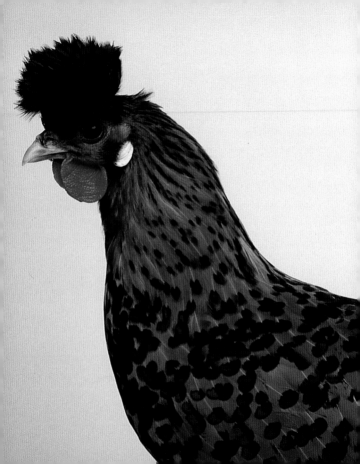

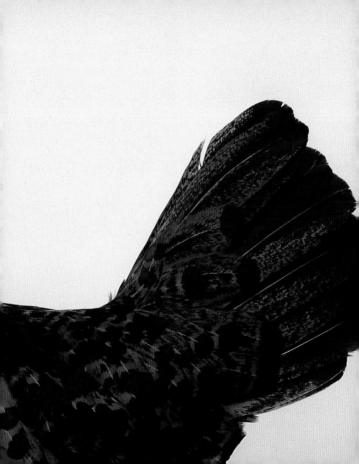

APPENZELLER SPITZHAUBEN
Silver Spangled Hen

PRECEDING PAGES:

APPENZELLER SPITZHAUBEN
Golden Spangled Hen

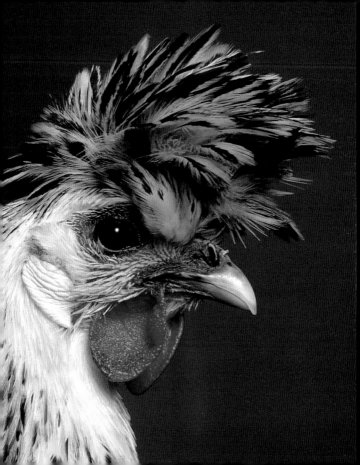

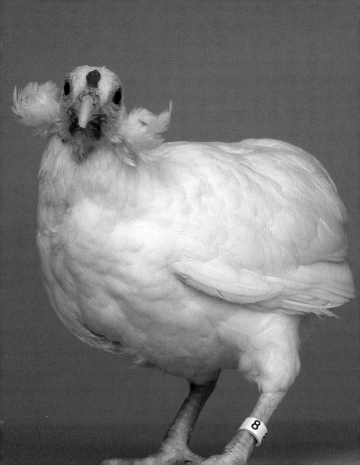

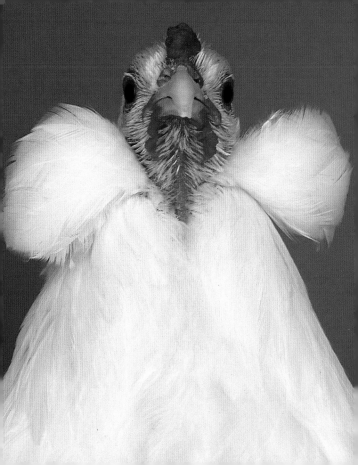

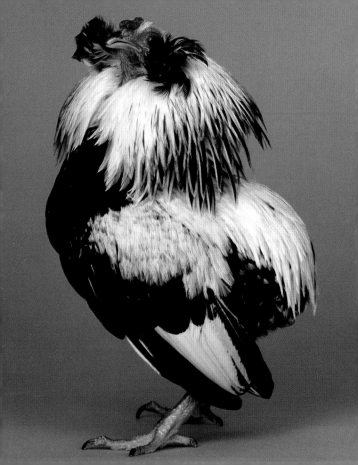

ARAUCANA *Silver Duckwing*

PRECEDING LEFT PAGE:

ARAUCANA
White Rumpless Hen

PRECEDING RIGHT PAGE:

ARAUCANA *White*

ARAUCANA *Silver Duckwing*

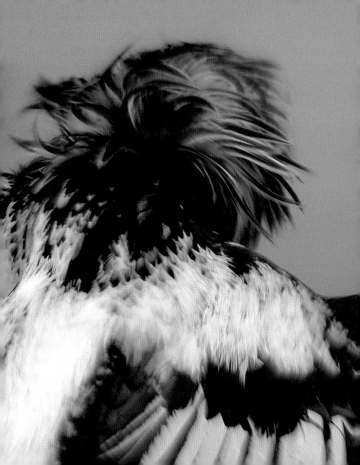

OPPOSITE AND OVERLEAF:

ARAUCANA *Golden Duckwing*

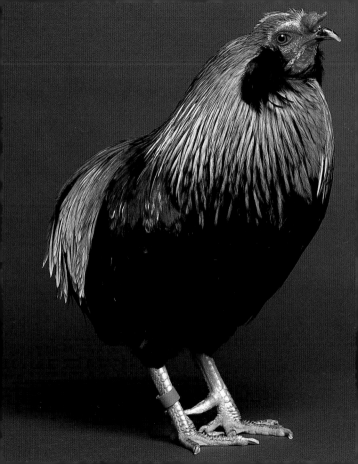

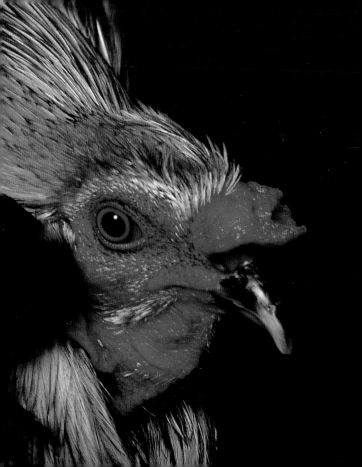

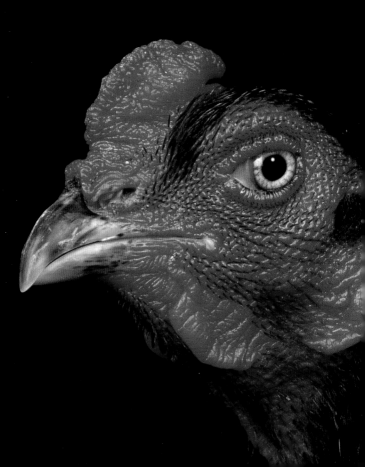

ASIL *Black*

OVERLEAF:

BELGIAN BEARDED D'UCCLE
Mille Fleur Hen

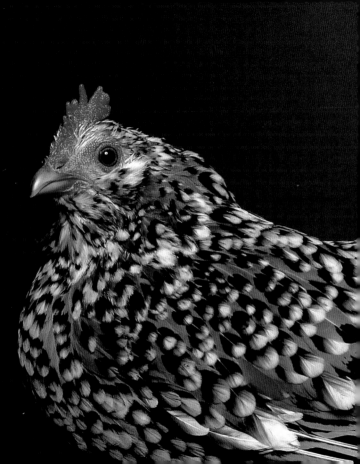

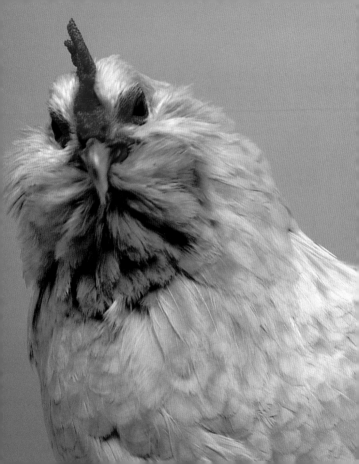

BRABANT *Gold Spangled*

PRECEDING PAGES:

BELGIAN BEARDED D'UCCLE
Porcelain

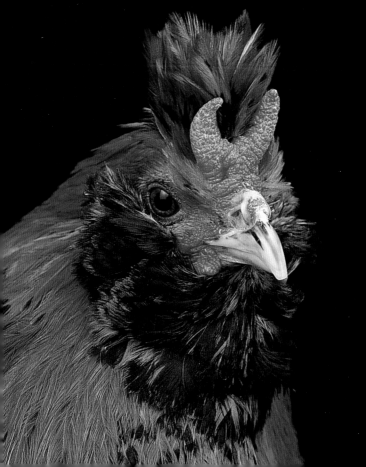

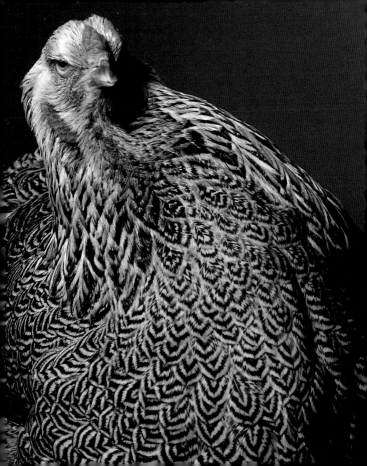

BRAHMA *Dark Hen*

BRAHMA *Dark Hen*

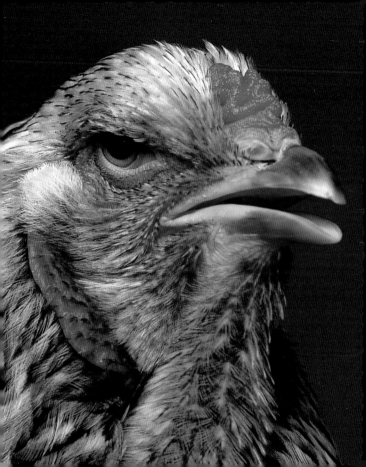

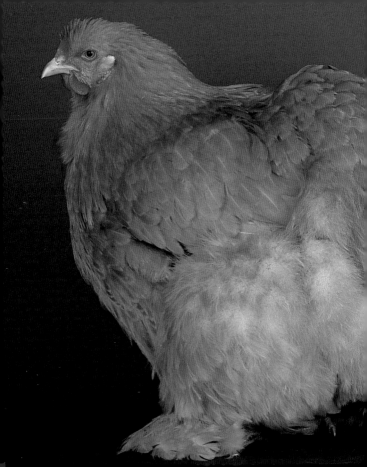

COCHIN *Buff Pullet*

OVERLEAF LEFT PAGE:
COCHIN *Splash Hen*

OVERLEAF RIGHT PAGE:
COCHIN *Barred*

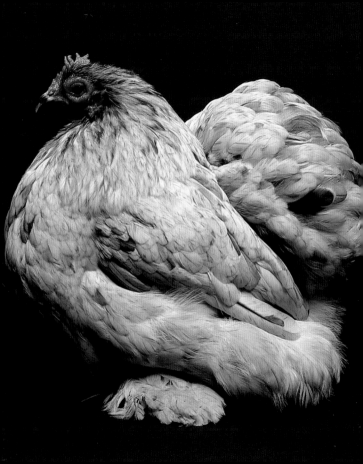

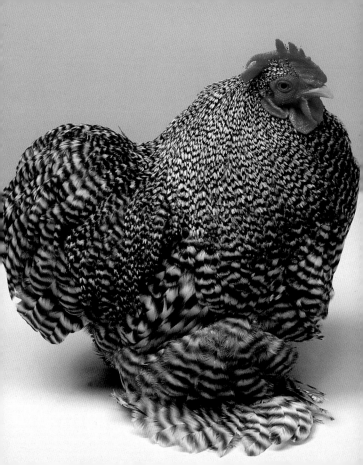

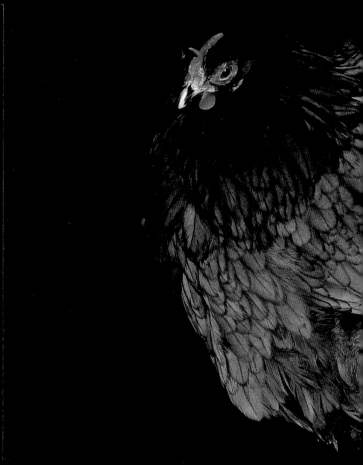

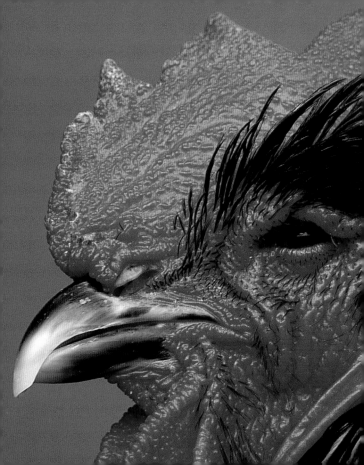

COCHIN *Black*

PRECEDING PAGES:
COCHIN *Blue Hen*

COCHIN FRIZZLE *White*

OVERLEAF:
COCHIN FRIZZLE *Bantam Birchen*

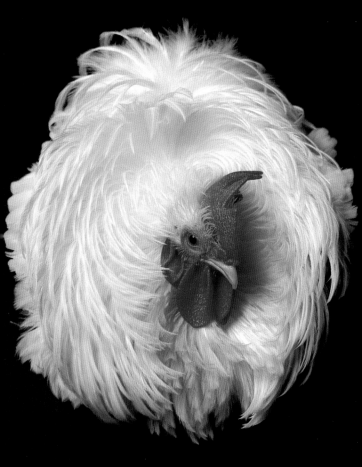

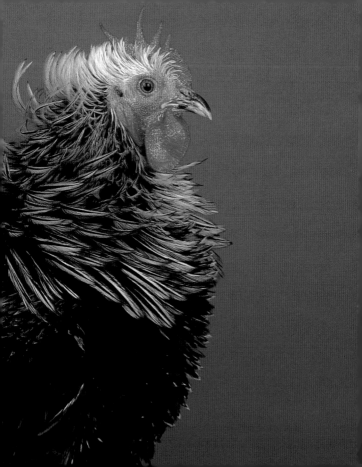

CORNISH *Bantam Dark Hen*

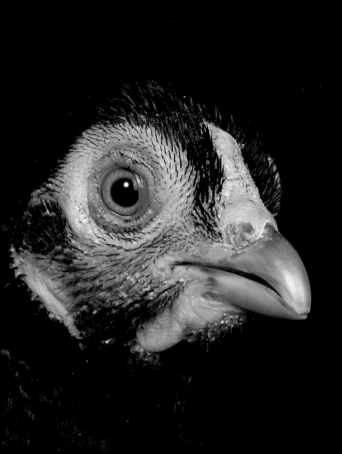

CORNISH *White*

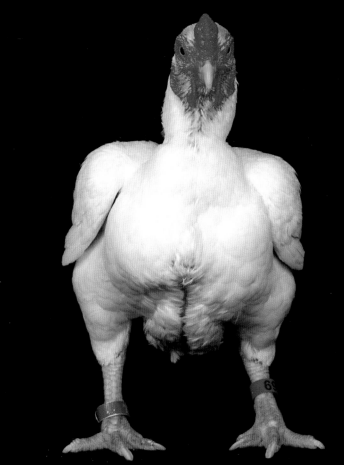

CORNISH *White Laced Red*

OVERLEAF:

DUTCH BANTAM *Crele*

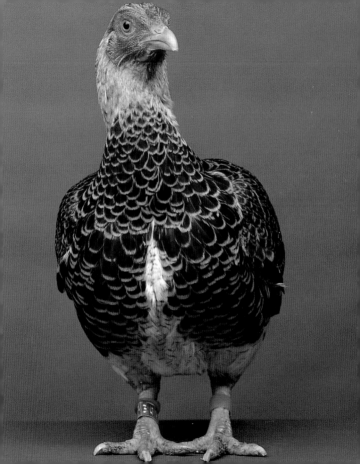

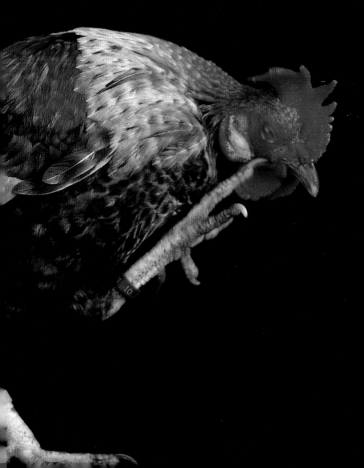

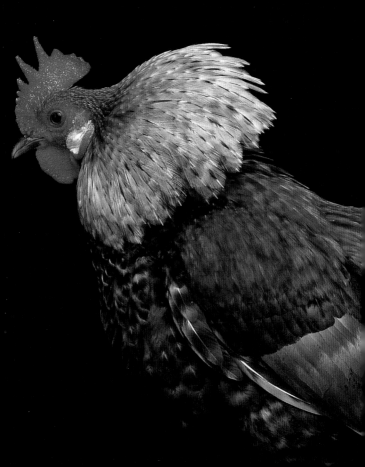

DUTCH BANTAM *Crele*

FAVEROLLES *Salmon*

OVERLEAF:
HAMBURG *Silver Spangled*

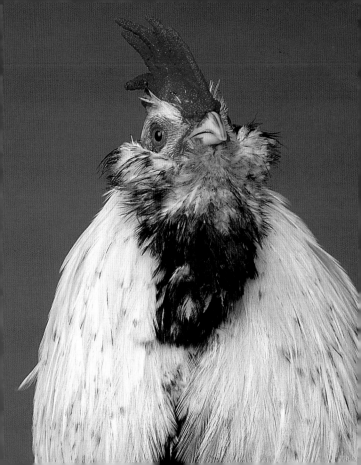

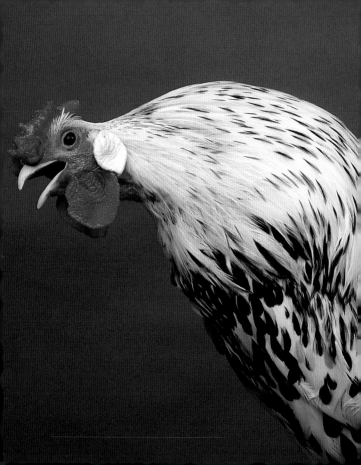

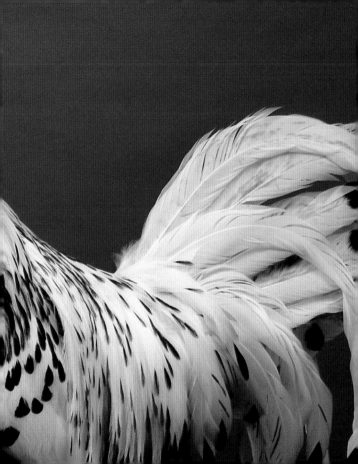

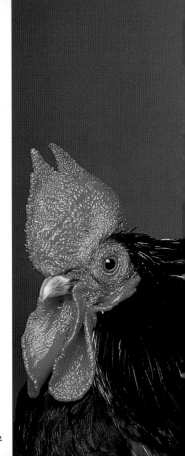

JAPANESE *Black*

OVERLEAF:
JAPANESE *Black Tailed Buff*

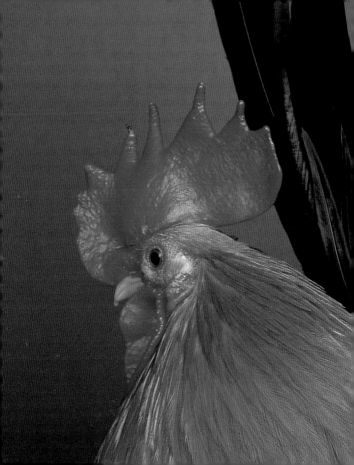

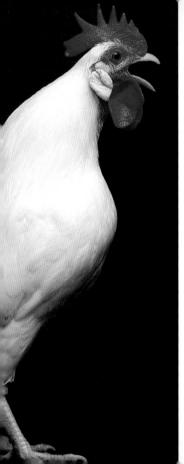

LEGHORN *Bantam White*

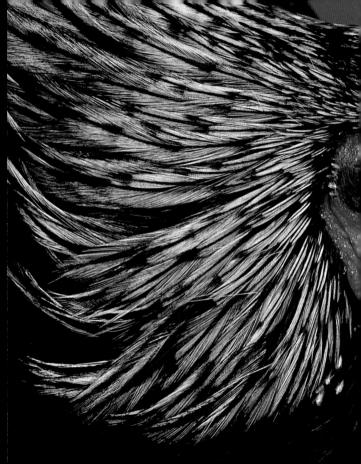

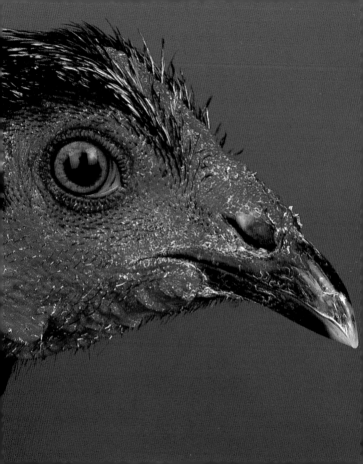

NAKED NECK *Black*

PRECEDING PAGES:

MODERN GAME *Birchen*

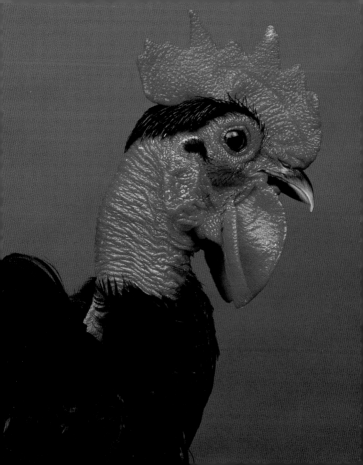

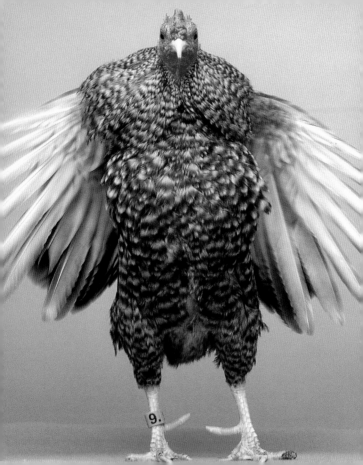

OLD ENGLISH GAME *Bantam Crele*

OVERLEAF:
OLD ENGLISH GAME *Bantam White*

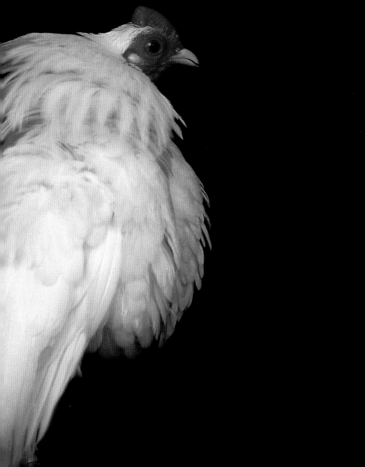

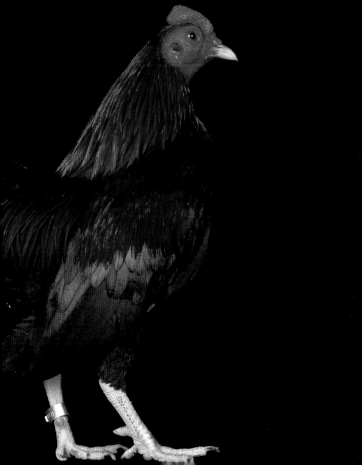

OLD ENGLISH GAME *Crele*

PRECEDING PAGES:

OLD ENGLISH GAME
Black Breasted Red

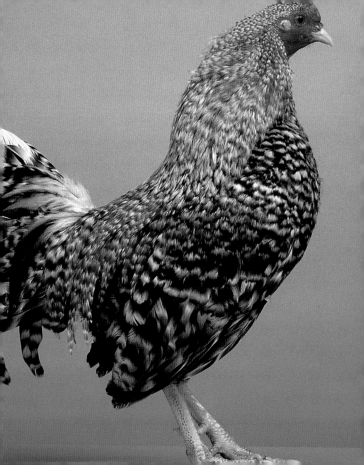

ORPINGTON *Buff*

OVERLEAF:

PLYMOUTH ROCK FRIZZLE
White Pair

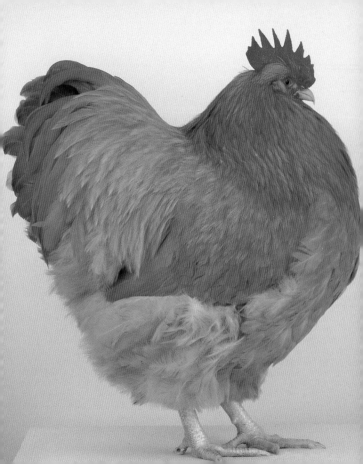

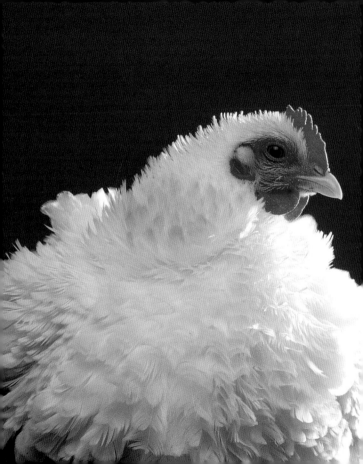

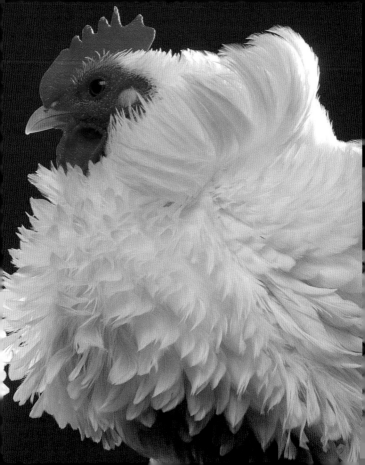

POLISH *White*

OVERLEAF:
POLISH *White Crested Blue*

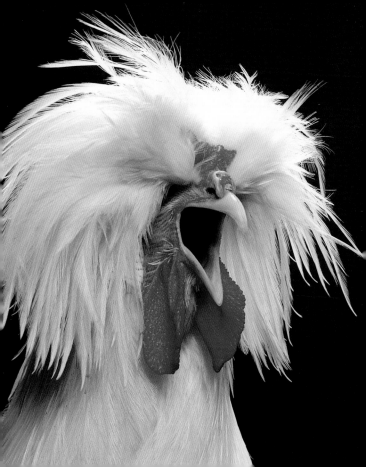

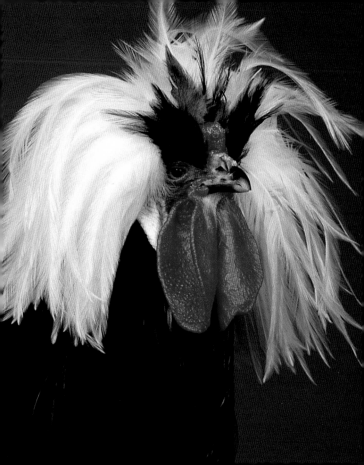

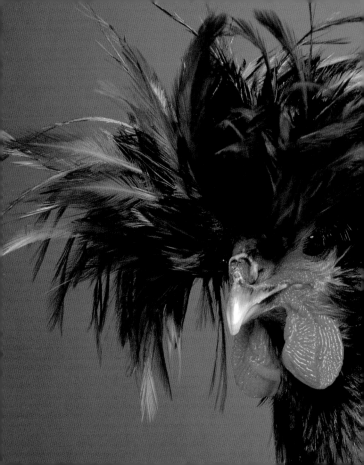

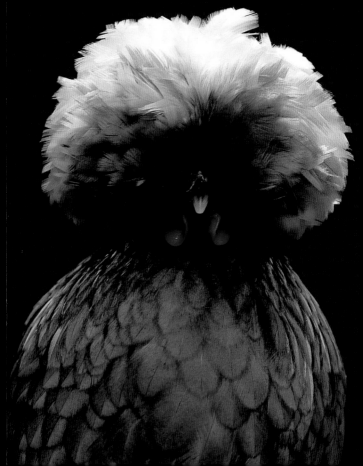

POLISH *White Crested Blue Hen*

PRECEDING PAGES: POLISH *Golden*

POLISH *White Crested Buff Hen*

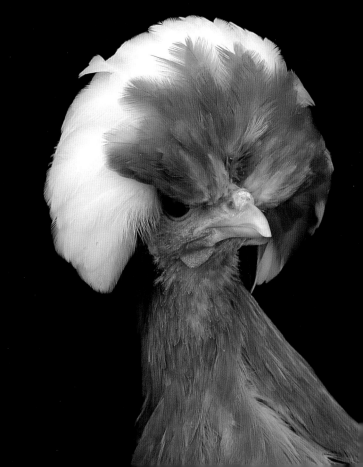

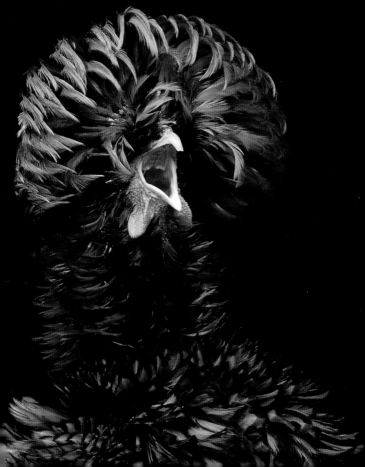

POLISH FRIZZLE *Golden Laced*

POLISH FRIZZLE *Bantam White*

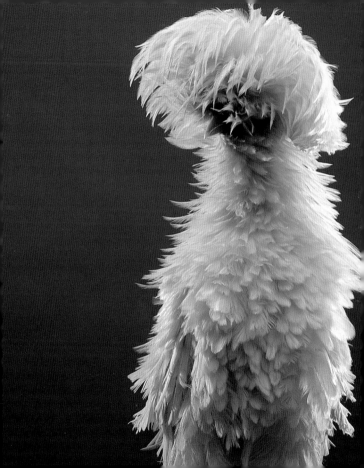

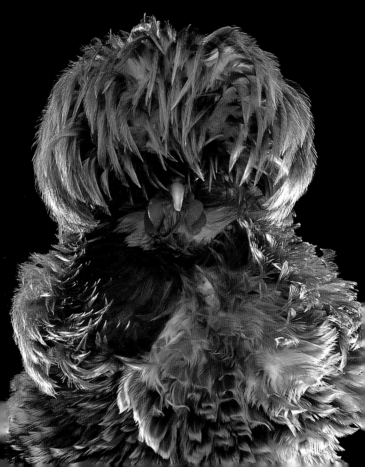

POLISH FRIZZLE *Chamois*

RED JUNGLE FOWL

OVERLEAF:

ROSECOMB *Pearl Gray*

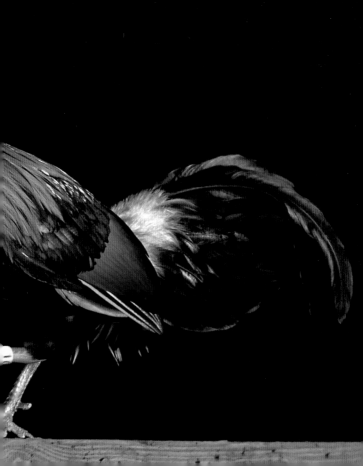

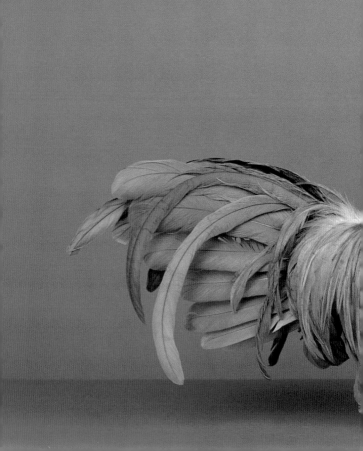

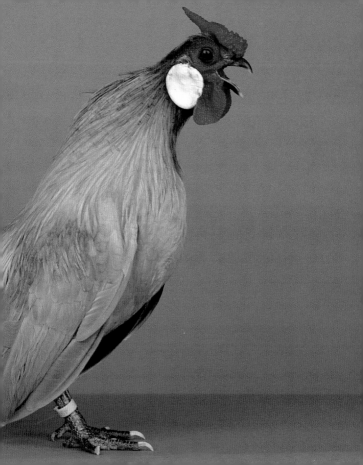

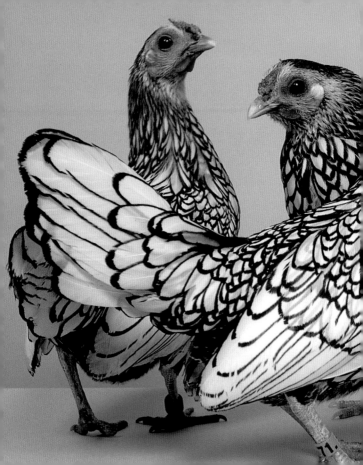

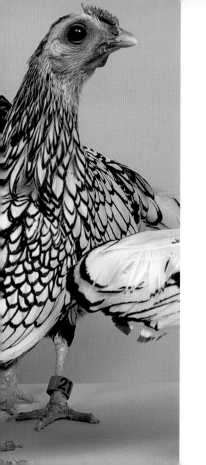

SEBRIGHT *Silver Hens*

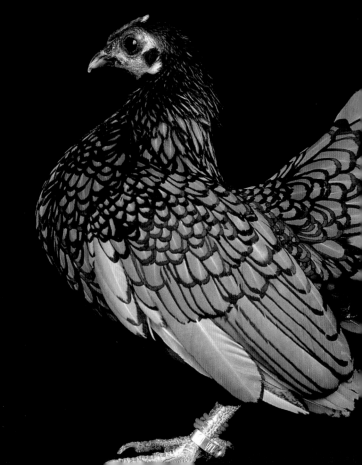

SEBRIGHT *Golden Hen*

OVERLEAF: SHAMO *Dark*

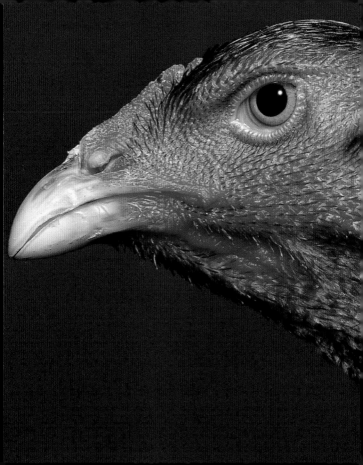

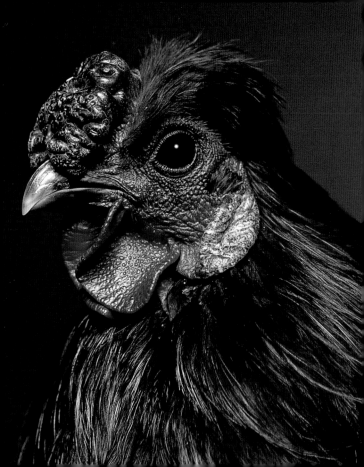

SILKIE *Non-Bearded Black*

OVERLEAF LEFT PAGE:
SILKIE *Bearded Buff Pullet*

OVERLEAF RIGHT PAGE:
SILKIE *Bantam Bearded White Hen*

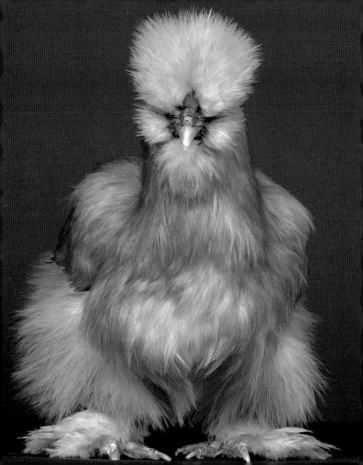

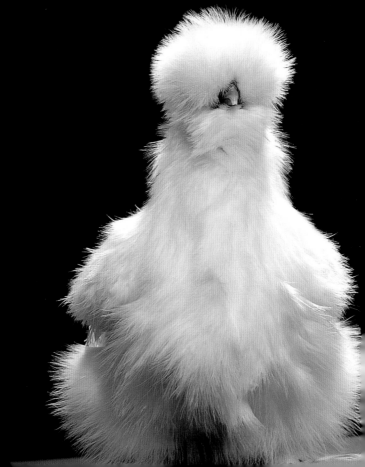

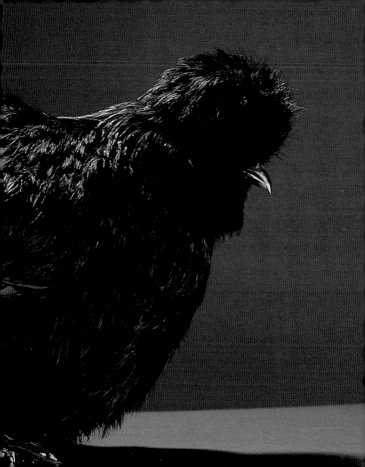

SILKIE *Non-Bearded White Hen*

PRECEDING PAGES:

SILKIE *Bantam Bearded Black*

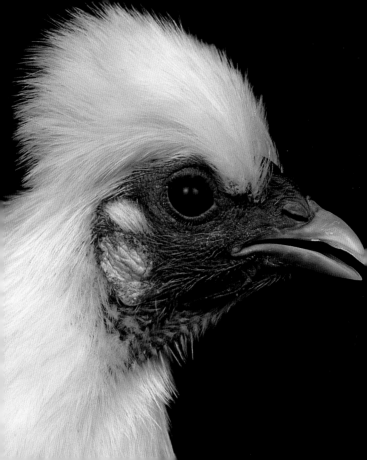

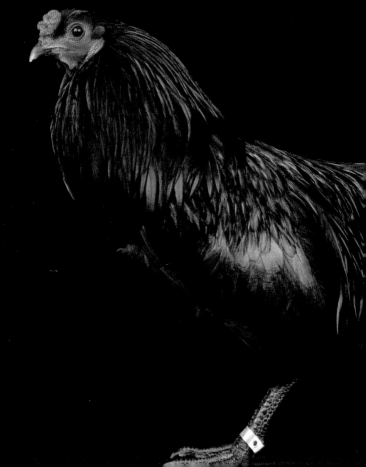

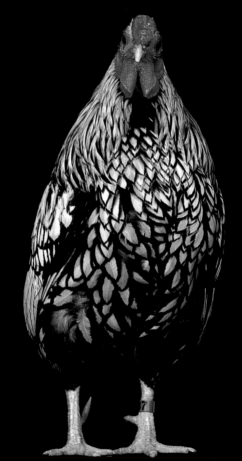

WYANDOTTE *Silver Laced*

PRECEDING PAGES:
SUMATRA *Black*

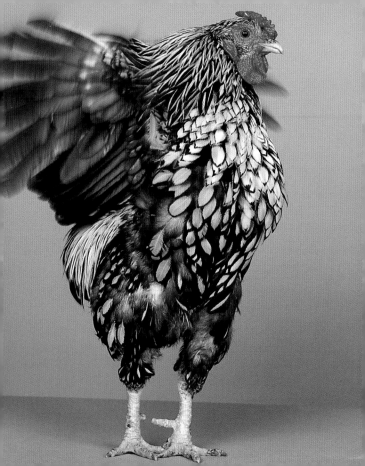

WYANDOTTE *Bantam Silver Laced*

OVERLEAF:

YOKOHAMA *Red Shoulder Cockerel*

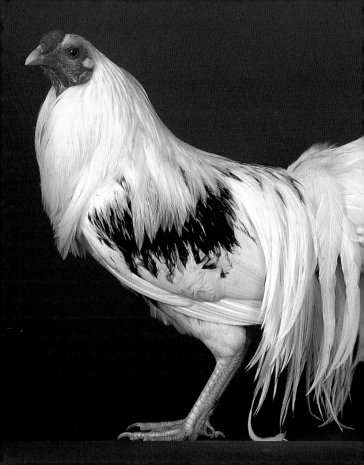

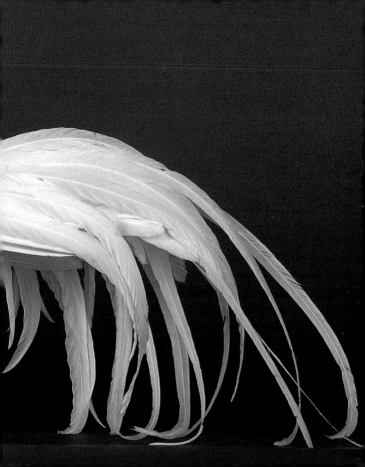

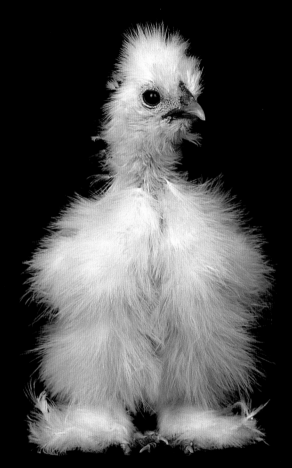

Chicks & Eggs

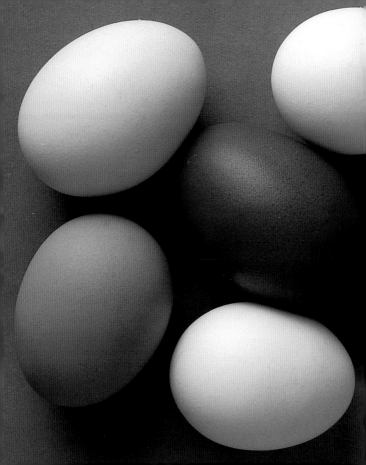

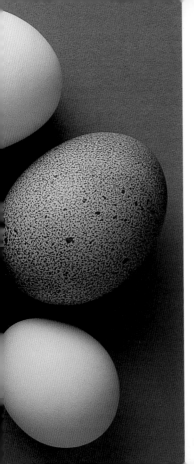

EGGS *Standard and Bantam*
(Darkest and Speckled Eggs
are Welsummer)

OVERLEAF:
POLISH *White Chicks*

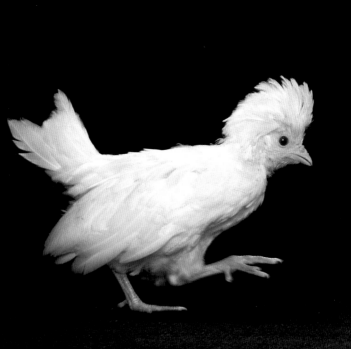

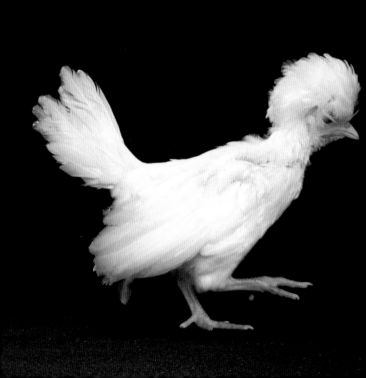

CUBALAYA
Black Breasted Red Chicks

OVERLEAF:

MIXED BANTAM CHICKS

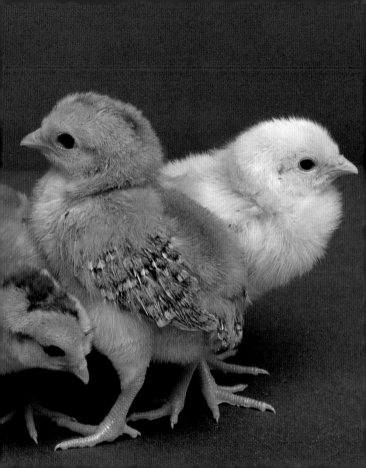

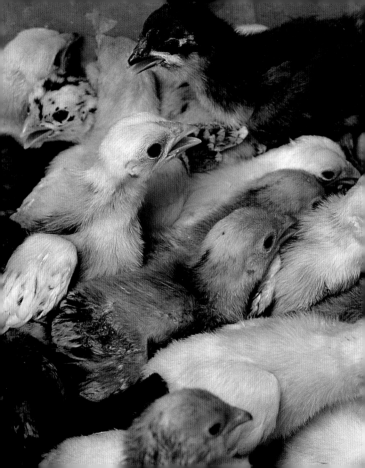

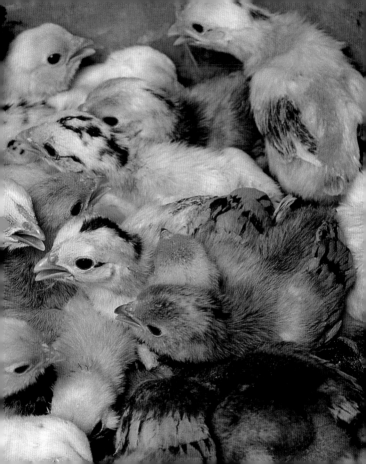

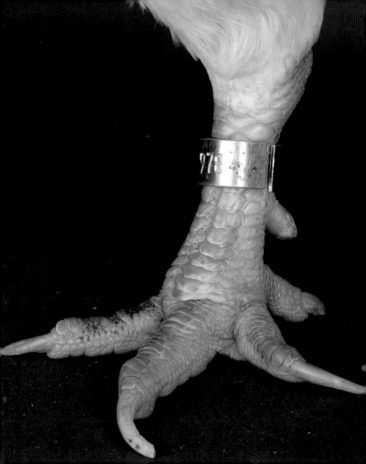

Legs, Feet
& Spurs

OPPOSITE:

CORNISH *White*

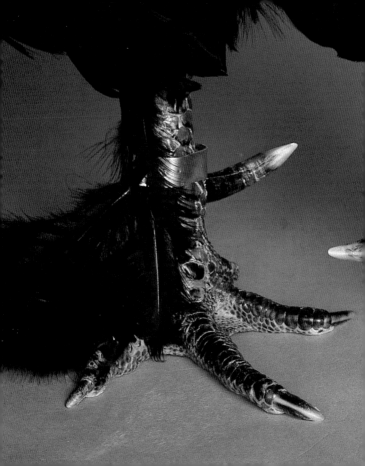

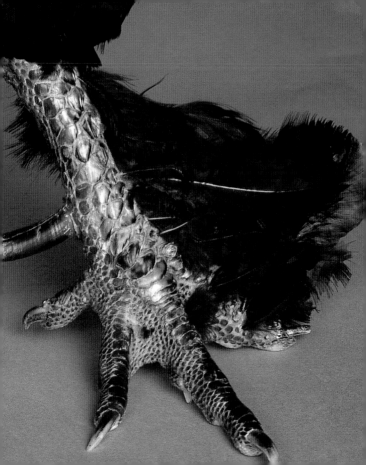

CUBALAYA *Black Breasted Red*

PRECEDING PAGES:
LANGSHAN *Black*

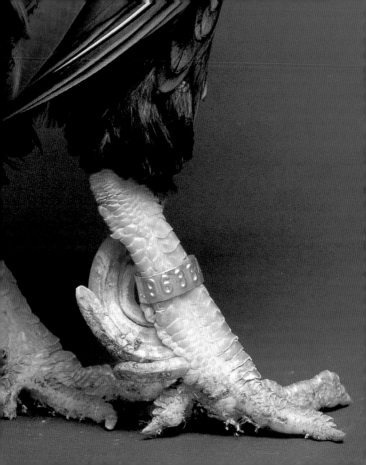

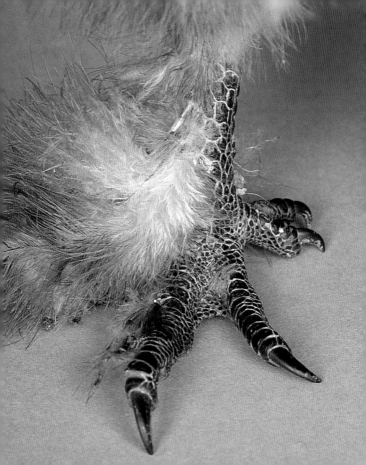

SILKIE *Gray*

OVERLEAF:

OLD ENGLISH GAME
Bantam Black

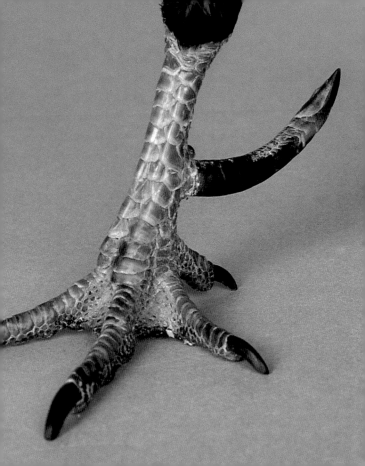

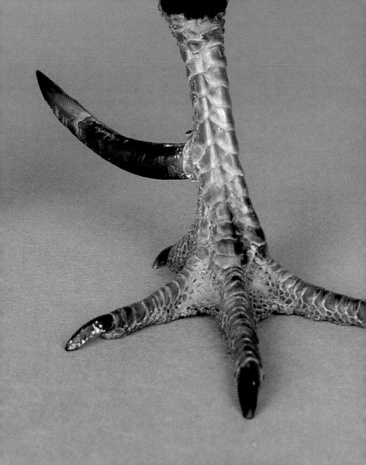

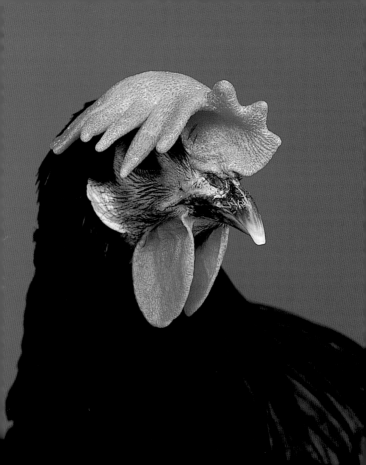

Single & Split Combs

LEGHORN
Single Comb White Cockerel

OVERLEAF LEFT PAGE:
ROSECOMB *Bantam White*

OVERLEAF RIGHT PAGE:
WYANDOTTE *White Cockerel*

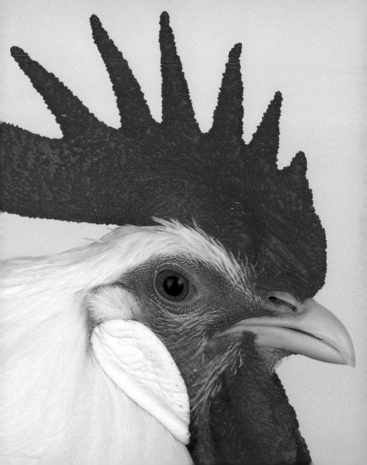

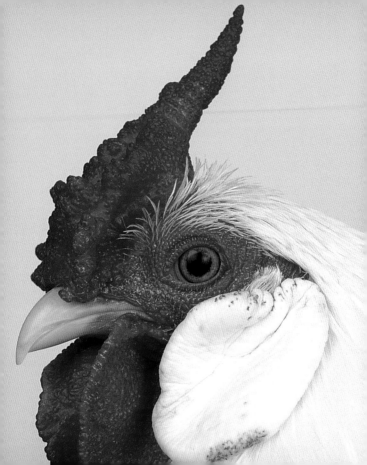

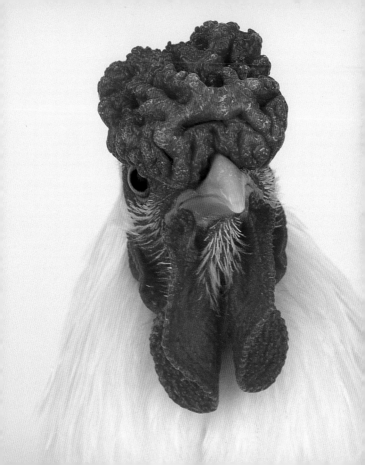

HAMBURG *Silver Spangled*

OVERLEAF LEFT PAGE:
MINORCA *Black*

OVERLEAF RIGHT PAGE:
ROSECOMB *Blue*

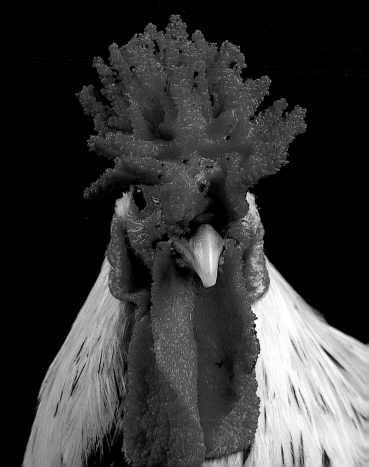

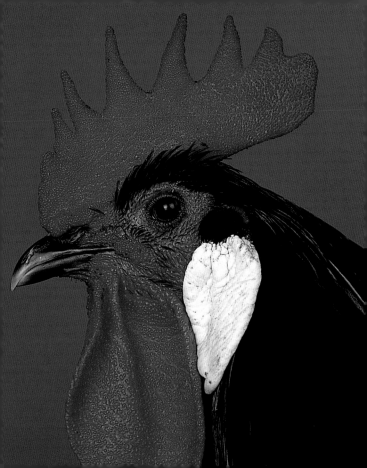

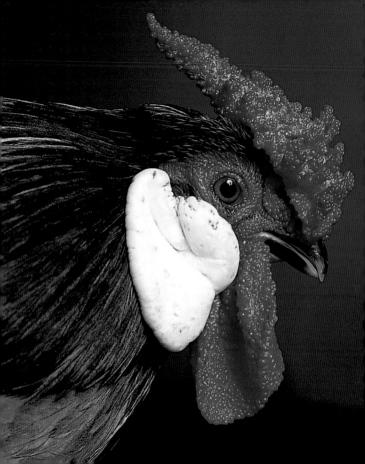

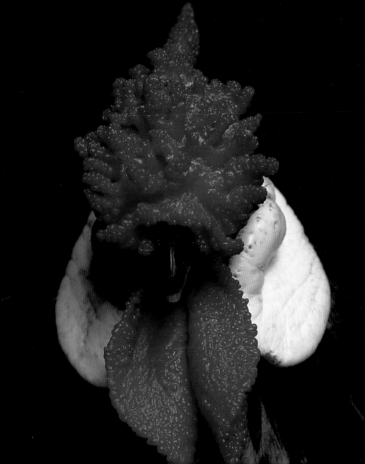

ROSECOMB *Black*

OVERLEAF LEFT PAGE:

APPENZELLER SPITZHAUBEN
Silver Spangled

OVERLEAF RIGHT PAGE:

OWLBEARD *White-Spangled Buff*

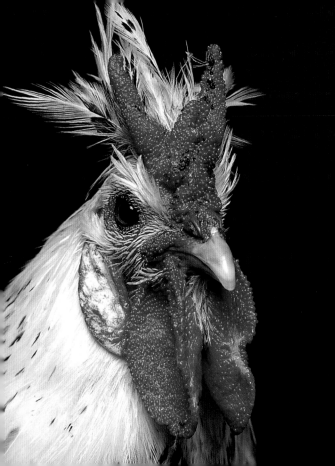

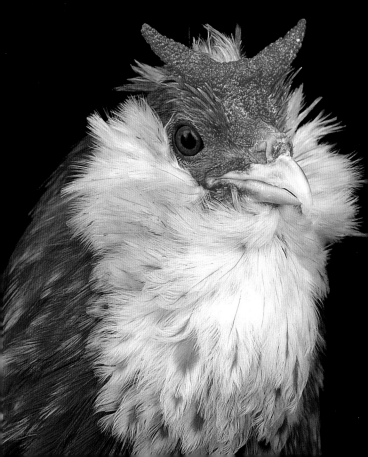

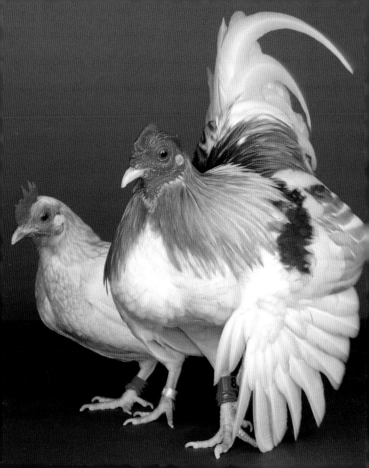

Pairs

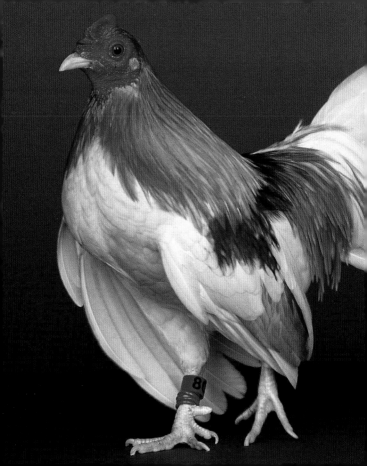

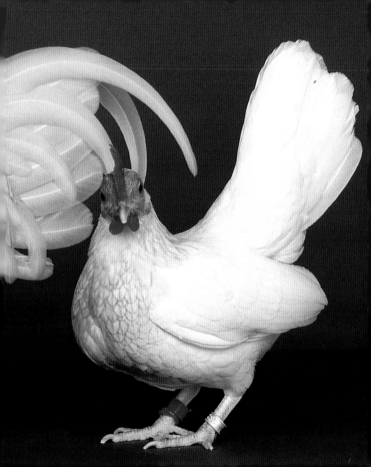

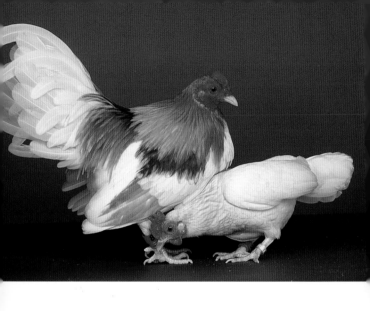

OLD ENGLISH GAME
Red Pyle Pair,
male (left) and female

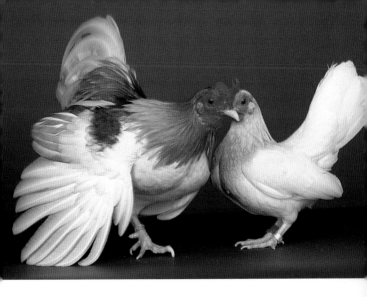

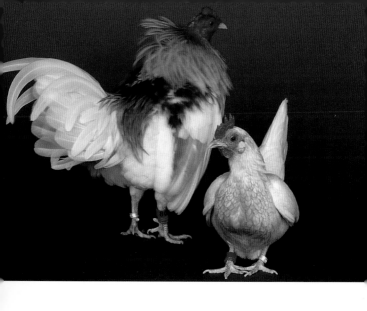

OLD ENGLISH GAME
Red Pyle Pair,
male (left) and female

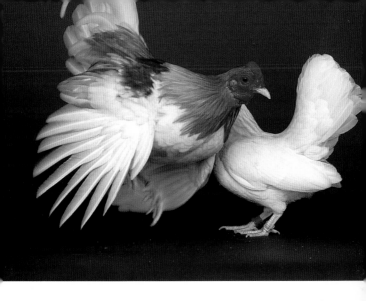

LANGSHAN *Black and*
OLD ENGLISH GAME
Bantam Black

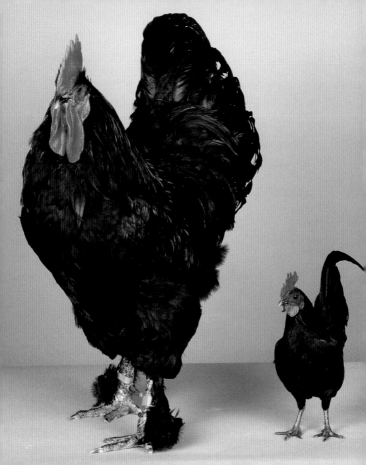

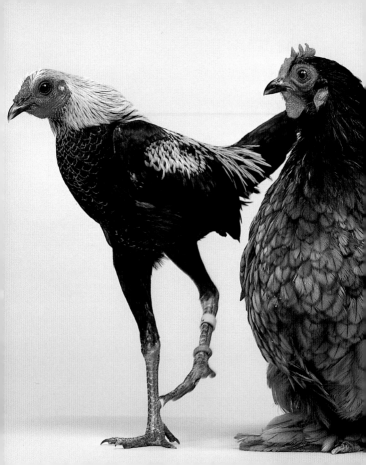

MODERN GAME
Birchen Cockerel and
COCHIN *Bantam Blue Hen*

OVERLEAF:

MODERN GAME *Wheaten and*
COCHIN *Bantam Partridge*

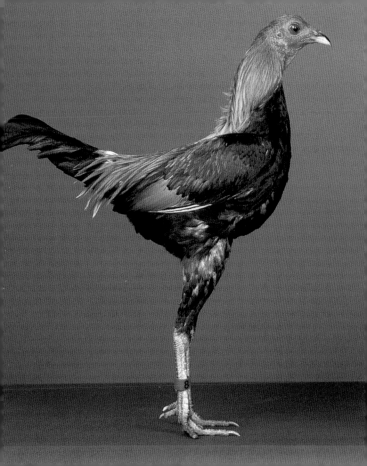

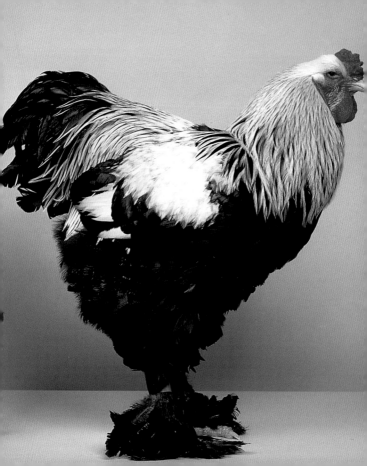

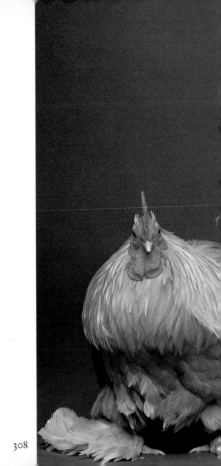

COCHIN *Buff Standard and Bantam*

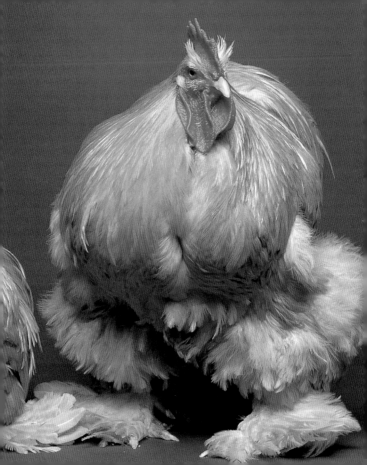

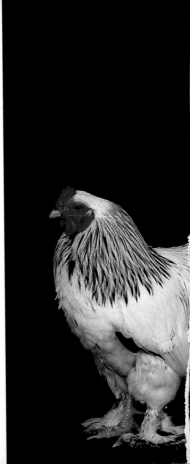

BRAHMA
Light Standard and Bantam

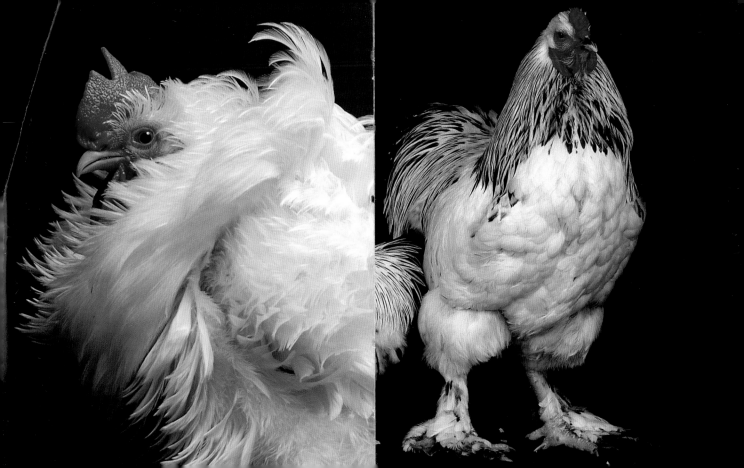

CUBALAYA *Black Breasted*
Red with Hens

Acknowledgments

Several people have been helpful to me in this project, but none more than Hans Schippers. He gave so generously of his time, his knowledge, and his personal contacts. His scholarship on all aspects of world poultry is matched by his prolific energy as an author on this and other animal subjects. His many popular books and articles are often illustrated by his own excellent photographs. At the same time, he has somehow remained busy as an academic biologist, first as a professor and now as a professor emeritus of biology.

I would also like to thank those who have invited me into their homes and barns to photograph chicks and chickens: Cy Hyde in New Jersey, Rick and Karen Porr in Pennsylvania, Paul Kuhl and his family in New Jersey, Arie Boland in the Netherlands, and John Castagnetti in Massachusetts. John was also extremely helpful with advice and with sharing his extensive knowledge and his library.

OPPOSITE: PLYMOUTH ROCK FRIZZLE *White*

I am indebted to Lorna Rhodes of the American Poultry Association and to Loyl Stromberg for many helpful conversations, and similarly to Rudiger Wandelt, Mike Hatcher, and Ned Newton. I enjoyed frequent phone sessions with Fred Hams in England, and he was my cheerful and enthusiastic guide at the Rare Breeds Center near his home in Kent. I had a very fruitful day of photography at the Domestic Foul Trust in Worcestershire and for this I am extremely grateful to Mrs. Bernie Landshoff, who is rather modest about being a distinguished vet, and to Stan Jones. Mr. Welling was my host at the Nederlands Pluimvee Museum in Barneveld, where I took pictures of some fine examples of Dutch breeds.

For my initial introduction to the world of show chickens, I thank various people who were at *LIFE Magazine* when I photographed these wonderful birds for them: writer Daphne Hurford for discovering this world for us, for finding a first-class show in California, and for selecting the most interesting specimens; and John Loengard and Mel Scott for entrusting me with this assignment as well as many others involving animals both wild and domestic.

I also want to thank organizers of poultry shows who helped with my needs for working space and were adaptable and coop-

erative at times when they were very busy with other concerns: Arlene Sliker and Jo Miller (Sussex County, NJ), Joel Henning and Rick Hare (Hamburg, NY), Dave Adkins and Tim and Susan Bowles (Lucasville, OH), Sal Lico (Rhinebeck, NY), Bob Murphy, Edie Rochette, Bob and Lorna Rhodes and Brian Knox (Topsfield, MA), P. Kroon and A. Bleyenberg (Kernhemshow, Ede, Holland), and David Hacket and Dick Ricketts (Stratford-on-Avon).

Naturally, my publishers at Harry N. Abrams, Inc., deserve credit for quickly perceiving the potential of this subject and for their continued enthusiasm as the work progressed, in particular editor Harriet Welchel and designer Carol Robson, who worked on the original edition of the book.

Finally, there are the dozens of people who gladly offered their extraordinary birds for photography, keeping a careful watch on those that were restless or adventurous. I hope that some of these people will feel repaid for their kindness when they see how handsome and remarkable the birds can look when exposed to studio lighting, and that they will be glad that the beauty and character of these great chickens have been celebrated and preserved in this book.

Index of Breeds

..

Numbers refer to pages with illustrations.